Double Vision

MICHAEL AND PETER BENTON

Published in association with
The Tate Gallery, London

Hodder & Stoughton
LONDON SYDNEY AUCKLAND TORONTO

Poem Acknowledgments

The authors and publishers would like to thank the following for their kind permission to reproduce copyright material:

Tate Gallery Publications and the authors of the poems for the following from *With a Poet's Eye* (ed. Pat Adams): 'Paul Klee "They're Biting"' by Paul Muldoon, 'The Boyhood of Raleigh' by Roger McGough, 'Siesta' by Gareth Owen, 'Thank Heaven for Little Girls' by Sylvia Kantaris, 'Samuel Palmer's "Coming From Evening Church"' by Charles Causley, 'A Chair in my House' by Jenny Joseph, 'Leaving the Tate' by Fleur Adcock; Martin Secker & Warburg Limited for 'Entr'acte' from *Homing* (1987) by John Mole; Michael Longley for 'Man Lying on a Wall: Homage to L. S. Lowry'; Anna Adams for 'Jean Arnolfini and his Wife' from *Dear Vincent* (1986) published by Littlewood Press; Laurence Pollinger Ltd and New Directions Publishing Corp. NY for 'Short Story on a Painting of Gustav Klimt' by Lawrence Ferlinghetti © 1976 from *Endless Eye* published by New Directions Publishing Corp. NY; New Directions Publishing Corp. NY and Carcanet Press for 'Children's Games', 'The Dance', 'Landscape with the Fall of Icarus' by William Carlos Williams from *William Carlos Williams Collected Poems Vol II 1939–1962* copyright © 1962 William Carlos Williams; Martyn Crucefix for 'George and the Dragon'; U. A. Fanthorpe and Peterloo Poets for 'Not My Best Side' from *Side Effects* (1978) and 'La Débâcle. Temps Gris' from *A Watching Brief* (1987); Harold Rosen for 'Andromeda' by Connie Rosen; W. H. Allen and Co plc for 'Van Gogh, July 1890' by B. C. Leale from *Leviathan and Other Poems* and 'Sketch by Constable' by B. C. Leale from *Voices in the Gallery* published by Allison and Busby; Colin Rowbotham for 'The Artist Arles, 1890'; Enitharmon Press for 'Vincent' and 'Letter to Vincent' by Phoebe Hesketh from *New and Collected Poems: Netting the Sun* (1989); Houghton Mifflin Company, Boston, for 'The Starry Night' by Anne Sexton from *Frameworks for Writing*: Faber and Faber Ltd for 'Musée des Beaux Arts' by W. H. Auden from *Collected Poems*, 'The Snow-Shoe Hare' by Ted Hughes from *Under the North Star* (1981), 'Summer Home 1969' by Seamus Heaney from *Selected Poems 1965–1975* (1980); Hamish Hamilton for the extracts from *Chatterton* (1987) by Peter Ackroyd; Carcanet Press for 'Poor Boy: Portrait of a Painting' by John Ash from *The Goodbyes* (1982) and 'Vignettes (I)' by Grevel Lindop from *Tourists* (1987); Ted Hughes/Olwyn Hughes for 'In Breughel's Panorama' by Sylvia Plath © Ted Hughes from *The Colossus* (1972) by Sylvia Plath published by Faber and Faber Ltd © Ted Hughes 1967; Oxford University Press for 'Girls on the Bridge' by Derek Mahon from *The Hunt by Night* (1982); John Calder (Publishers) Ltd for 'The Scream' by B. C. Leale from *The Colours of Ancient Dreams* (1984); Dolmen Press for 'Nighthawks' and 'Automat' by Julie O'Callaghan from *Edible Anecdotes* (1983).

Every effort has been made to trace the copyright holders of the following poems:
James O. Taylor 'Van Gogh, Cornfield with Crows'
Francis Barker 'Just Passing'
Joseph Langland 'Fall of Icarus: Breughel'

British Library Cataloguing in Publication Data
Benton, Michael *1939–*
 Double Vision: reading paintings – reading poems –
reading paintings
 1. European paintings. Critical studies 2. Poetry in
English. Critical studies
 I. Title II. Benton, Peter *1942–*
 759.94

ISBN 0 340 51852 9

First published 1990

Typeset by Wearside Tradespools, Fulwell, Sunderland
Printed in Great Britain for Hodder and Stoughton Educational, a division of Hodder and Stoughton Limited, Mill Road, Dunton Green, Sevenoaks, Kent by Colorcraft Ltd, Hong Kong

CONTENTS

CONTENTS

4

Painting Acknowledgments

The authors and publishers would like to thank the following for their kind permission to reproduce material in this volume:

The Tate Gallery, London for 'The Boyhood of Raleigh' by John Everett Millais (p. 19), 'The Siesta' by John Frederick Lewis (p. 27), 'Alleluia' by Thomas Gotch (p. 37), 'Coming from Evening Church' by Samuel Palmer (p. 52), 'The Lady of Shalott' by John William Waterhouse (p. 68), 'Chatterton' by Henry Wallis (p. 76), 'Snowstorm: Steam-Boat off a Harbour's Mouth' by J. M. W. Turner (p. 114), 'Carnation, Lily, Lily, Rose' by John Singer Sargent (p. 115); Tate Gallery, London/The Trustees of the Estate of Gwen John for 'A Lady Reading' by Gwen John (p. 110); Tate Gallery, London/David Hockney for 'Mr and Mrs Clark and Percy' by David Hockney (p. 111); Tate Gallery, London/David Inshaw/Waddington Galleries Ltd for 'Badminton Game' by David Inshaw (p. 111); Tate Gallery, London/Luke Gertler for 'The Merry-go-Round' by Mark Gertler (p. 112); Tate Gallery, London/ Patrick Caulfield for 'Pottery' by Patrick Caulfield (p. 113); Tate Gallery, London/Francis Bacon for 'Seated Figure' by Francis Bacon (p. 116); Courtauld Institute Galleries, University of London (Courtauld Collection) for 'La Loge' by Pierre-Auguste Renoir (p. 8); City of Salford Art Gallery and Museum for 'Man Lying on a Wall' by L. S. Lowry (p. 11); DACS/Tate Gallery, London for 'They're Biting' by Paul Klee (p. 15) 1920, Aquarell, Oelfarbezeichnung, italienisiches Ingres gelb-grunlich/ 31.3 × 23.5 cm/signiert links oben/sammlung Tate Gallery © Cosmopress Geneva and DACS London 1990; Dover Publications Inc, NY for engravings by Thomas Bewick (p. 17) and 'The Ship of Death' by Gustav Doré (p. 73); The Trustees, the National Gallery, London for 'The Arnolfini Marriage' by Jan Van Eyck (p. 21), 'Saint George and the Dragon' by Paolo Uccello (p. 30), 'Landscape with Cypresses Near Arles' by Vincent Van Gogh (p. 43), 'The Haywain' by John Constable (p. 57); Osterreichische Galerie, Vienna for 'The Kiss' by Gustav Klimt (p. 24); Southampton City Art Gallery, UK, for 'The Rescue of Andromeda' by Edward Burne-Jones (p. 34); Vincent Van Gogh Foundation/National Museum Vincent Van Gogh, Amsterdam for 'Wheatfield Under Threatening Skies with Crows' by Vincent Van Gogh (p. 40 and front cover); The Museum of Modern Art, New York for 'The Starry Night' by Vincent Van Gogh (p. 46), oil on canvas, 29 × 36 1/4" (73.7 × 92.1 cm). Collection, The Museum of Modern Art, New York. Acquired through the Lillie P. Bliss Bequest. Photograph © 1990 The Museum of Modern Art; The Trustees of the British Museum for 'The Sick Rose' (p. 50) and 'The Tyger' (p. 51) both by William Blake; The Ashmolean Museum, Oxford for 'Late Twilight' by Samuel Palmer (p. 55); The Board of Trustees of the Victoria and Albert Museum for 'Willy Lott's House Near Flatford Mill' by John Constable (p. 58); Calouste Gulbenkian Foundation, Lisbon, Portugal for 'Break-up of the Ice Near Lavacourt' by Claude Monet (p. 59); Wadsworth Atheneum, Hartford, Connecticut for 'The Lady of Shalott' by William Holman Hunt from The Ella Gallup Sumner and Mary Catlin Sumner Collection (p. 64); Viking Press NY for 'The Snow-Shoe Hare' by Leonard Baskin from Under the North Start (p. 75); Kunsthistorisches Museum, Vienna for 'Children's Games' (p. 83) and 'Peasant Dance' (p. 86) both by Pieter Bruegel; The Prado Museum, Madrid for 'The Triumph of Death' by Pieter Bruegel (p. 88 and details), 'The Third of May, 1808' (p. 104), 'Panic' (p. 107) and 'Two Strangers' (detail) (p. 108) all by Francisco Goya, copyright © Prado Museum, Madrid, all rights reserved; Patrimoine des Musées Royaux des Beaux-Arts, Brussels for 'Landscape with the Fall of Icarus' by Pieter Bruegel (p. 92); Museum Ludwig, Cologne and Rheinische Bildarchiv, Cologne for 'Girls on the Bridge' by Edvard Munch (p. 96); Nasjonalgallariet, Oslo/Oslo Kommunes Kunstsamlinger for 'The Scream' by Edvard Munch (91 × 73.5 cm) (p. 98); The Art Institute of Chicago for 'Nighthawks' by Edward Hopper (p. 101) 1942, oil on canvas 76.2 × 144 cm, Friends of American Art Collection, 1942.51 © 1990 The Art Institute of Chicago. All rights reserved; Des Moines Art Center, Iowa for 'Automat' by Edward Hopper (p. 103).

INTRODUCTION

Double Vision is a collection of paired paintings and poems. In some instances, the painter and poet are the same person (for example, William Blake or Samuel Palmer); in others, the pictures are illustrations of poems, as in the sixth section, but most of the pairings have come about because the writers have responded to particular paintings by composing poems about them. Thus the book invites *your* responses to two arts which here complement each other in a unique way.

We have often started with the painting. One of our aims is to help you to give each painting more than a casual glance. We have chosen pictures which, both for the poets and for you, are worth pausing over. When a painting catches the eye, we commonly spend no more than a couple of minutes looking at it before moving on. These first impressions are important, often memorable sources of pleasure; but, we can learn to look longer. The approaches we suggest extend this time and pleasure: we urge you to 'read' the details of the paintings, often recording what you see in note form, and to share your responses with others. New poems, too, can be puzzling at first; often they may seem just a blur of words until we learn to read more slowly.

Both paintings and poems need *time*. The approaches we have suggested are varied and dictated by the nature of the particular pairing, but our overall purpose has been to encourage you to dwell on both the pictures and the words. You will find they have many things in common:

- the *stories* embedded in the paintings or created by the poets;
- the *point of view* that a poet and painter adopts;
- the *formal composition* – the way the words are organised and laid out as a poem, or the shapes, lines and colours from which a painting is made;
- the *significant details* which the painter selects as pleasing images, or symbols of his or her idea and which may become woven into the imagery of a poem;
- the *feelings and thoughts* that complement each other in these 'sister arts'.

We have presented the material in twelve sections, both to help the reader find a way through it and to make links between paintings that fall into natural groupings. The sections have been governed by the paintings rather than by the poems. We are aware that there are other links to be made and we have suggested some of these in *Making Connections* (p. 118, especially numbers 7 and 8). We feel that it would be helpful to *start* with *Reading Paintings . . . Reading Poems*, since this introduces such devices as jotting around paintings/poems, 'mapping'

responses in sequence, making diagrams and so on, that are used elsewhere in the book. Other sections can then be chosen for study according to taste and interest or, as in a gallery, depending on what catches your eye.

In the approaches we have outlined we have attempted to keep a balance between information about the paintings/poems, questions or prompts to focus you on details, and more exploratory, 'open' invitations to express your responses. Sometimes it is essential to have some historical information, for example, about Chatterton (p. 76), or to be alerted to aspects of a painter's technique (Van Gogh p. 39).

Occasionally, we have been deliberately directive, giving you several questions or prompts, as, for instance, with Samuel Palmer's *Coming from Evening Church* and Pieter Bruegel's *The Triumph of Death*. We have done so to encourage you to give paintings close scrutiny. Most of them after all were built up over many months of painstaking work, from preliminary sketches 'on location' and/or in a studio. There is much to be 'read' in the details. However, the most important aspect of all the approaches suggested here is your personal response to the paintings and poems. Usually, we have suggested some ways into the material and invited you to explore them. Above all, we hope you enjoy the experience.

Of course, there are many pictures and poems that we have had to omit through lack of space and there are obvious limitations when focusing exclusively on *pairings* of artists and poets – there are few paintings by women from which to choose, and our selections tend to be mostly European. If you want to explore further we have listed some books on p. 124. We particularly recommend the two Tate Gallery publications, *With A Poet's Eye* and *Voices in the Gallery*. We started there – why don't you?

Michael and Peter Benton

1 Reading Paintings
. . . Reading Poems . . .

When we look at a painting or read through a poem, our attention moves from detail to detail as we build up our first impressions. Below are two examples of the sorts of notes that can be made on paintings and poems. Both show you ways of monitoring your own responses which you can use with other paintings and poems throughout this book.

PIERRE-AUGUSTE
RENOIR (French)
The Box (La Loge), 1874.
Courtauld Institute
Galleries, University of
London

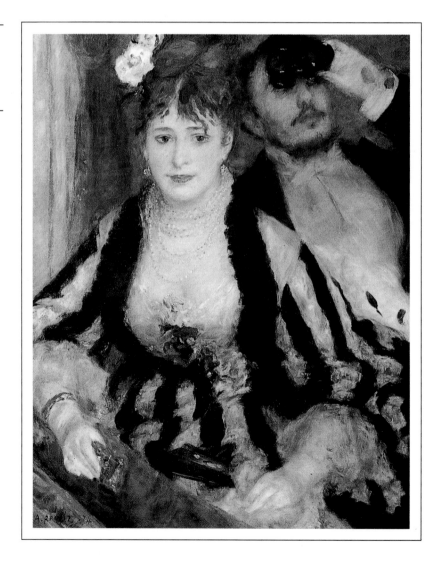

Jotting Your Own Responses

In the first example we have shown some of the comments and questions that occurred to us about Renoir's painting *La Loge* and John Mole's companion poem *Entr'acte*. Study the painting and the poem carefully *before* you look at our thoughts around each.

— *Entr'acte* —

The cuff-link whispers to the glove.
Such elegance, and all for love.

The glove confesses to the glass:
Oh how slowly five acts pass.

The glass is lifted to the eye:
Show me a tear I cannot dry.

The eye says nothing to the heart:
Such elegance, and all for art.

John Mole

Who are they? A well-to-do couple seated in a theatre/opera box.

What's their relationship?
He's looking up. At somebody else in the theatre? Her eyes are elsewhere. On the stage? Audience? Us? He's intent on something. Is she? Or is she bored?

She is the central focus and occupies 4/5ths of the space. He's squeezed into a triangle, top right; he seems out of focus.

Wealth and opulence in all the details — necklace, earrings, bracelet, small gold opera glasses, handbag and expensive clothes.

Colours. Black stripes contrasted with soft yellows, creams and whites. Even some blue. Splashes of red and pink in flowers and skin tones.

They exude youth, money, style and social confidence.

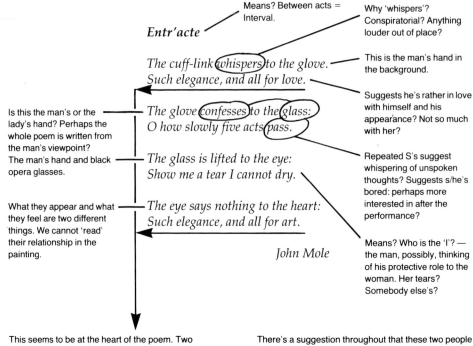

Means? Between acts = Interval.

Why 'whispers'? Conspiratorial? Anything louder out of place?

Entr'acte

The cuff-link (whispers) to the glove.
Such elegance, and all for love.

This is the man's hand in the background.

Is this the man's or the lady's hand? Perhaps the whole poem is written from the man's viewpoint? The man's hand and black opera glasses.

The glove (confesses) to the (glass:)
O how slowly five acts (pass.)

Suggests he's rather in love with himself and his appearance? Not so much with her?

The glass is lifted to the eye:
Show me a tear I cannot dry.

Repeated S's suggest whispering of unspoken thoughts? Suggests s/he's bored: perhaps more interested in after the performance?

What they appear and what they feel are two different things. We cannot 'read' their relationship in the painting.

The eye says nothing to the heart:
Such elegance, and all for art.

John Mole

Means? Who is the 'I'? — the man, possibly, thinking of his protective role to the woman. Her tears? Somebody else's?

This seems to be at the heart of the poem. Two complementary and ambiguous lines. All is done for art can mean either all is done in honour of the occasion; or it can mean that all is done as artifice — the dressing up and elegance is for the purpose of artfully snaring a lover.

There's a suggestion throughout that these two people are on display: part of the show themselves? Literally showing off — though tastefully, of course.

Poem's structure with its four neat couplets and regular four beat line matches the elegance of the couple. All is suitably smooth and polished.

Mapping Your Own Responses

This approach will help you discuss *how* you read a painting. The numbered responses in the diagram show the 'mental walk' that we took around the picture.

On your own

- Look carefully at L. S. Lowry's painting *Man Lying on a Wall* and quickly jot down your first responses to the following:
 - What do you see, and in what order do you first see it? It isn't a complicated picture with a lot of detail.
 - Number the things you focused on in the order you noticed them . . . brick wall, clock tower, etc. Spend no more than two minutes on this activity.
 - Then transfer your 'mental walk' around the picture to a sketch of it. Here's one of ours opposite.

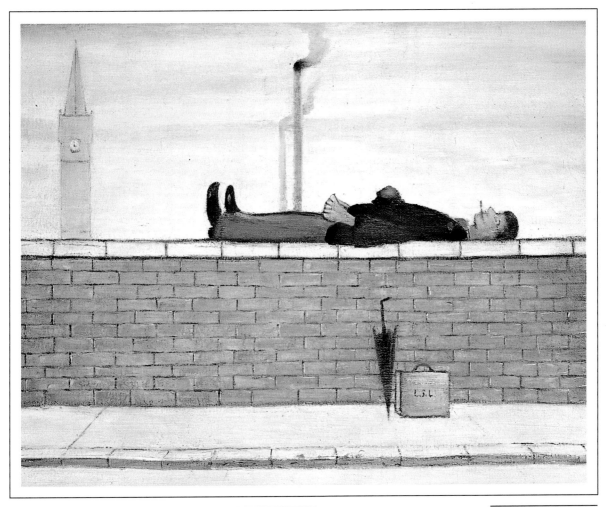

L. S. LOWRY (British)
*Man Lying On a Wall,
1957. Salford Museum
and Art Gallery*

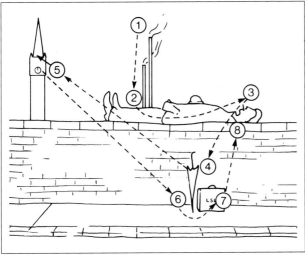

- Now, retrace your steps around the painting and jot down any thoughts that flash through your head as your eyes move to different parts of the picture.

In pairs or small groups

- Compare the similarities and differences in your own 'mental walk' around the picture with those taken by others in your group.
- How is the man lying? Where else might you see figures in a similar position?
- Think about the composition of the painting and why Lowry might have included the details and the shapes he has.
- What do you think is the mood of the picture? Happy? Sad? Peaceful? Resigned? Bored? Angry? . . . Something else?

Now hear Michael Longley's poem *Man Lying on a Wall: Homage to L. S. Lowry* read aloud.

— *Man Lying on a Wall* —

Homage to L. S. Lowry

You could draw a straight line from the heels,
Through calves, buttocks and shoulderblades
To the back of the head: pressure points
That bear the enormous weight of the sky.
Should you take away the supporting structure
The result would be a miracle or
An extremely clever conjuring trick.
As it is, the man lying on the wall
Is wearing the serious expression
Of popes and kings in their final slumber,
His deportment not dissimilar to
Their stiff, reluctant exits from this world
Above the shoulders of the multitude.

It is difficult to judge whether or not
He is sleeping or merely disinclined
To arrive punctually at the office
Or to return home in time for his tea.
He is wearing a pinstripe suit, black shoes
And a bowler hat: on the pavement
Below him, like a relic or something
He is trying to forget, his briefcase
With everybody's initials on it.

Michael Longley

On your own

- Spend five or ten minutes numbering and jotting your responses around the poem. Your jottings might be about ideas or feelings the poem suggests, how the poet's reading of the painting compares with yours, any puzzling bits, lines or words that appeal to you, and so on.

In pairs or small groups

- Compare your readings of the poem.
- In the first part of his poem, the man's attitude and expression remind Michael Longley of a clever conjuring trick, an effigy on a tomb in church, a body borne in a funeral procession. Talk about these images and how the words create them.
- In common with most people who look at the picture, the poet is a little puzzled about what is going on. In the last five lines of the poem he suggests what he thinks may be part of the answer. Why might he suggest that L.S.L. could be 'everybody's initials'?

You may find it helpful to know that Lowry, who lived all his life in and around Manchester becoming famous for his industrial scenes peopled by 'match-stick figures', was seventy years old when he painted this picture. It originated from an incident when he was travelling by train and saw a tired businessman lie down on a wall in this unconventional way. Writing about this painting, Julian Spalding noted:

> Lowry has inscribed his own initials on the suitcase; he himself might have been tempted to take such a rest. He had, moreover, similarly embellished a coffin in a little funeral picture painted by his friend Geoffrey Bennett. The man's hat lies on his chest. Could it be his last rites? The spire points up, the black umbrella points down. Has Lowry in fact laid himself to rest, in a rather unconventional position, in his own industrial landscape?
>
> (from *Lowry* by Julian Spalding)

Or could it be simply that Lowry is acknowledging his own description of himself as 'one of the laziest men I know'?

Ideas for Coursework

The Story in the Painting: Write the story that *you* see in either of these paintings.

Double Vision: You have now looked closely at the paintings and poems. Choose one pairing and write an essay which draws together your ideas about

- *how* you 'read' the painting and the poem
- how the poem interprets the painting
- and what judgements you come to about the relationship between the two.

Details: Take a line or phrase from one of the poems, or a detail from either painting, and build a piece of writing of your own from this starting point.

Poems and Pictures:

- Look again at the two characters in *La Loge*. She gazes in our direction; his eyes are hidden and his attention elsewhere. Focus on either or both figures and write a poem which captures what they might be thinking or feeling.
- Imagine you are the man lying on the wall. Write a poem of your own that captures what you have decided he might be thinking as he lies there.
- Take one of the characters from the pictures and paint or draw what you imagine that he or she sees.
- Select from either of the poems a line or phrase which created a strong picture in your mind's eye. Draw or paint what you saw.

We hope you found the approaches to these first two pairs of paintings and poems helpful. They can be used to monitor your responses to other paintings in the rest of the book.

The coursework ideas above focus only upon these pairings but, again, they can be adapted easily to help you to develop coursework from other sections.

PAUL KLEE • *They're Biting*

PAUL MULDOON • *Paul Klee: 'They're Biting'*

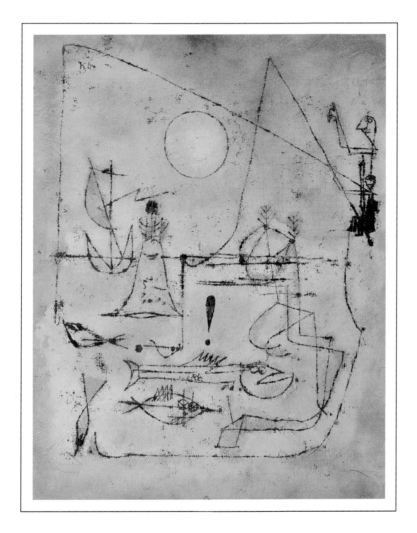

PAUL KLEE (Swiss)
*They're Biting, 1920. The
Tate Gallery, London*

On your own

What do you see?

- List what people, objects and creatures you think you can identify.
- Can you say anything about the style and mood of the picture?

In groups

- Compare your notes and ideas.

Now read through Paul Muldoon's poem.

— *Paul Klee: 'They're Biting'* —

The lake supports some kind of bathysphere.
an Arab dhow

and a fishing-boat
complete with languorous net.

Two anglers
have fallen hook, line and sinker

for the goitred,
spiny fish-caricatures

with which the lake is stocked.
At any moment all this should connect.

When you sent me a postcard of *They're Biting*
there was a plane sky-writing

I LOVE YOU over Hyde Park.
Then I noticed the exclamation-mark

at the painting's heart.
It was as if I had already heard

a waist-thick conger
mouthing NO from the fishmonger's

otherwise-drab window
into which I might glance to check my hair.

Paul Muldoon

In groups

- In the first ten lines of his poem, has Paul Muldoon read the details in the way you have?
- In the second half of his poem, what is suggested to him by the exclamation mark? What do you think might have been the nature of the message on the back of the postcard?

THOMAS BEWICK • *Roadmender*

GREVEL LINDOP • from *Vignettes: Poems for Twenty-One Wood Engravings by Thomas Bewick*

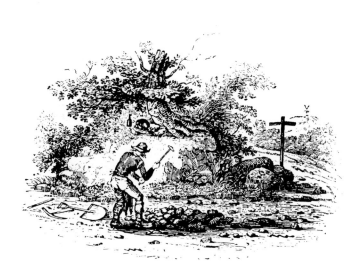

THOMAS BEWICK
(British)
Woodcuts, nineteenth century. Dover Pictorial Archive series

— I —

Out of some dream I wake to find myself
here between two blows of the sledge,
my task to break large stones to small stones
to be trodden under the horses' feet, chewed
by carriagewheels. The blackbird's curious eye
marks me when I look up. I throw myself into the stroke,
swing up again and he is still there
unmoved. The road like a river
turns its corner. When the shadows have turned
I shall eat dinner on the bank
staring at road metal,
pick, shovel and sledge.
Then hands will shape again to the helve,
smashed rock alternate
with a glimpse of the unsplintered world:
a windmill fading into the white sky,
a signpost pointing to nowhere and nowhere.

Grevel Lindop

17

Thomas Bewick was the father of modern wood engraving and during his lifetime (1753–1828) produced many hundreds of tiny, highly detailed book illustrations, all beautifully observed from nature. In another poem, Grevel Lindop wrote about Bewick that he 'as surely / As Blake or Palmer, traced one of the heavens, / That place where by sheer clarity of detail / All things become their archetypes'. Clarity of detail, though on a minute scale, is one of Bewick's hallmarks, as Grevel Lindop recognises in his poem: he, too, makes us stop and look with attention and understanding at this tiny scene which we might otherwise not *see*.

On your own

- Read the poem and see how many of the details match with those of the picture. Some are imaginary but most are accurate reflections of what is there.
- Write your own poem to match one of the other Bewick illustrations below trying to take a similar care to think yourself into the world of the picture.

JOHN EVERETT MILLAIS • *The Boyhood of Raleigh*

ROGER McGOUGH • *The Boyhood of Raleigh*

Sir Walter Raleigh was born in 1552 in South Devon and later led several voyages of discovery and expeditions to the American continent. He was executed in 1618 by James I.

This was one of the most popular British paintings during Victorian times. Part of its appeal was that it celebrated the idea of Empire by recalling the great age of discovery and worldwide exploration during the reign of Queen Elizabeth I.

The Victorians also liked paintings which told stories; so, thinking about the stories suggested in the picture is one way-in.

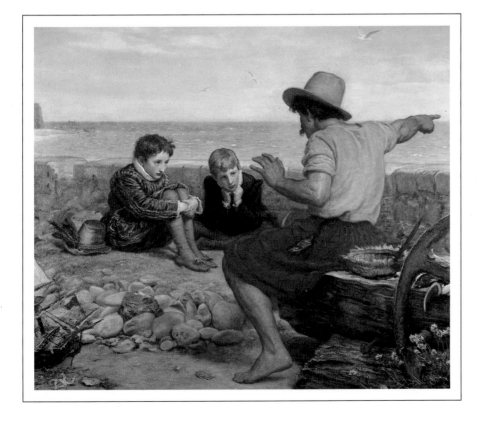

J. E. MILLAIS (British)
*The Boyhood of Raleigh,
1870. The Tate Gallery,
London*

19

On your own

- Look at the painting. What's happening here? Notice the details of clothing and objects. Notice the characters' expressions.
- Invent three speech/thought bubbles to capture what each character might be saying or thinking.

Now read the poem:

— *The Boyhood of Raleigh* —

Entranced, he listens to salty tales
Of derring-do and giant whales,

Uncharted seas and Spanish gold,
Tempests raging, pirates bold.

And his friend? 'God I'm bored.
As for Jolly Jack, I don't believe a word.

What a way to spend the afternoons,
The stink of fish, and those ghastly pantaloons!'

Roger McGough

In groups

- Talk about the way Roger McGough has interpreted the painting. Are his views at all like yours?

On your own

- Using your speech/thought bubbles as a starting point, write a short poem in couplet form which captures *your* interpretation of the picture.

JAN VAN EYCK • *The Arnolfini Marriage*

ANNA ADAMS • *Jean Arnolfini and his wife,*
painted by Jan Van Eyck

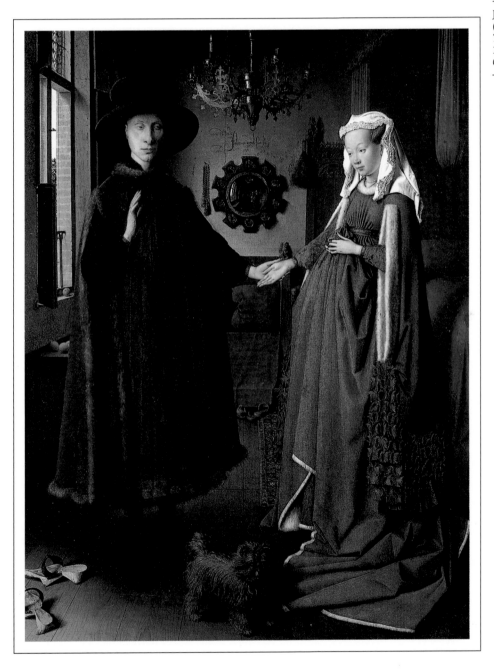

JAN VAN EYCK
(Dutch/Flemish)
The Arnolfini Marriage,
1434. The National
Gallery, London

First, look carefully at the painting, then read the following comments on it by E. H. Gombrich from *The Story of Art*:

> One of [Van Eyck's] most famous portraits . . . represents an Italian merchant, Giovanni Arnolfini, who had come to the Netherlands on business, with his bride . . . The picture probably represents a solemn moment in their lives – their betrothal. The young woman has just put her right hand into Arnolfini's left and he is about to put his own right hand into hers as a solemn token of their union. Probably the painter was asked to record this important moment as a witness, just as a notary might be asked to declare that he has been present at a similar solemn act. This would explain why the master has put his name in a prominent position on the picture with the Latin words *'Johannes de eyck fuit hic'* – (Jan Van Eyck was present). In the mirror at the back of the room we see the whole scene reflected from behind, and there, so it seems, we also see the image of the painter and witness.

The detail below shows the images in the convex mirror, supposedly those of Van Eyck and a friend greeting the newly-weds in the doorway. The frame of the mirror contains ten scenes from the Passion of Christ.

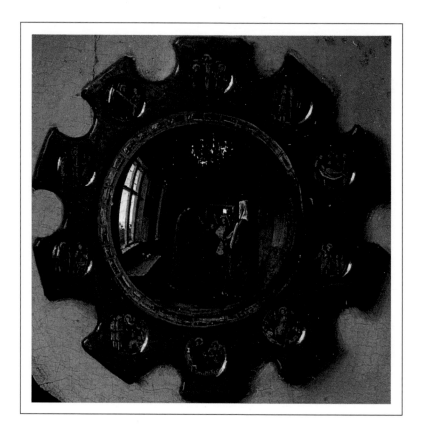

On your own

- Let your eye roam about the entire painting and jot down, as you go, all the details that you notice and any thoughts or questions that they raise in your mind.

Now, read Anna Adams' two-part poem and then make your own jottings about it as you did with the painting.

— *Jean Arnolfini and his Wife,* —
painted by Jan van Eyck

1. These two stand in their narrow room;
 five hundred years they've waited thus:
 her hand in his, one on her womb,
 his right hand raised, dismissing us.
 They would take off their fancy dress:
 his outsize hat, her grave-green gown:
 lie naked on that bed and kiss,
 but they are never left alone.
 Intruders in the convex glass
 keep children from their grownup game
 of love and marriage, playing house:
 Why don't the guests go home?
 Outside the window, in clear light,
 ripe cherries beckon birds to bite.

2. Illusions, durable through centuries,
 projected by a magic-lantern mind,
 enchanted into paint's paralysis,
 you wait to be let speak, or drop a hand.
 Young sir, well disciplined by staid attire,
 responsibility's absurd black hat
 snuffs out your animal, spontaneous fire,
 if your pale face be capable of that.
 She doesn't look into your lashless eyes
 but futureward; beneath her gown's green fold
 a child quickens. This anonymous
 deathbound manvessel, in voluminous
 green garments, may already sleep in mould,
 so, standing still, the masked lay-figure lies.

Anna Adams

In pairs

- As before, compare your notes and ideas with those of a partner.

On your own

● Finally, write a description for someone else which charts the stages
you went through in building up your understanding of the painting.
Record your first responses, your reactions to the picture in the light of
the information from Gombrich, and what you learned through jotting
down notes about the painting and the poem.

GUSTAV KLIMT ・ *The Kiss*

LAWRENCE FERLINGHETTI ・ *Short Story on a
Painting of Gustav Klimt*

GUSTAV KLIMT
(Austrian)
*The Kiss, 1907–8.
Osterreichische Galerie,
Vienna*

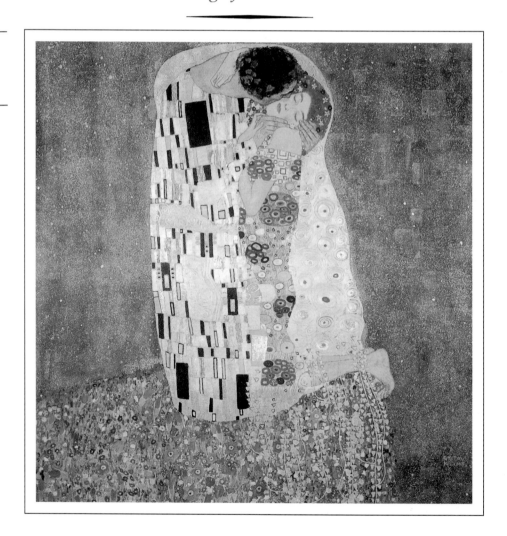

On your own

- Study the painting. Jot down any words or phrases that seem to you to capture the feeling and mood of the picture. Here are some questions you might like to ask yourself:
 - What words might you use to describe the man, the woman, their embrace, their cloaks?
 - What distinguishes the man's from the woman's cloak? Why do you think this is?
 - Where are they?

In pairs or small groups

- Once you have made your own notes, compare your thoughts with those of a partner or with those of others in your group.

Now listen to the poem being read aloud.

— *Short Story on a Painting of Gustav Klimt* —

They are kneeling upright on a flowered bed
 He
 has just caught her there
 and holds her still
 Her gown
 has slipped down
 off her shoulder
He has an urgent hunger
 His dark head
 bends to hers
 hungrily
And the woman the woman
 turns her tangerine lips from his
 one hand like the head of a dead swan
 draped down over
 his heavy neck
 the fingers
 strangely crimped
 tightly together
her other arm doubled up
 against her tight breast
her hand a languid claw
 clutching his hand
 which would turn her mouth
 to his

her long dress made
 of multicolored blossoms
 quilted on gold
her Titian hair
 with blue stars in it
And his gold
 harlequin robe
 checkered with
 dark squares
Gold garlands
 stream down over
 her bare calves &
 tensed feet
Nearby there must be
 a jeweled tree
 with glass leaves aglitter
 in the gold air
It must be
 morning
 in a faraway place somewhere
They
 are silent together
 as in a flowered field
 upon the summer couch
 which must be hers
And he holds her still
 so passionately
 holds her head to his
 so gently so insistently
 to make her turn
 her lips to his
her eyes are closed
 like folded petals
She
 will not open
 He
 is not the One

Lawrence Ferlinghetti

In pairs

- One writer comments about the picture: 'The woman's eyes are closed in ecstasy as he kisses her.' How does Ferlinghetti see the relationship between the man and the woman?

On your own

● Gustav Klimt was the son of a gold and silver engraver and was himself a craftsman and designer of murals. When he visited Ravenna in Italy about four years before he painted this picture he was bowled over by the richness and the intricate patterning of the mosaics he saw inside and outside the churches. Using your earlier notes about the painting, put yourself in Klimt's place and write a poem telling what you were trying to do, what feelings you were trying to capture in this picture.

JOHN FREDERICK LEWIS • *The Siesta*

GARETH OWEN • *Siesta*

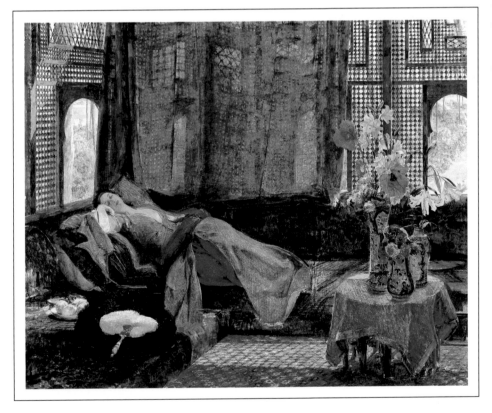

JOHN FREDERICK
LEWIS (British)
*The Siesta, 1876. The
Tate Gallery, London*

In pairs

● Look at the painting and read through the poem below.

— *Siesta* —

Each day at this same hour
He comes to her
His lady of the afternoons.
Behind closed lids she hears the whispering brush strokes
Gathering in the light, the windows and her sleeping form.
Her countenance is often in his dreams
But these are things not spoken of.
Outside the room where all this happens
In a splash of sunlight by the kitchen door
A maid trades amorous gossip with the gardener's boy
While shelling peas into her widespread lap:
A petal falls, someone puts out washing
And in the orchard among oranges
Her husband, whose idea it was,
Tends to his bees, his face inside a net.
'I'm working on your mouth,' the painter tells her.
She does not know his christian name.
Her shut lids tremble. Just so
She used to close her eyes in childhood
Feigning sleep or death
Then open them in sudden laughter
To see her father's great moon face
Filling the everywhere:
Then later he was further off
And later still an absence
Like a place she took her heart to ache in.
Remembering this, she feels herself
Absorbed into the room
And in the darkness there
Beyond the limits of herself
Senses the painter with his canvas gone away
And lines of curious, reverential strangers
Filing past the open door
To gaze on her
Like one already dead.

Gareth Owen

In pairs

● Concentrate on the poem and in two columns:

(i) list the eight individuals or groups who are mentioned in the poem, and

(ii) write down all the things we know about them.

In groups

● Working with another pair, compare your lists. Then, together, make a third list of those things in both the poem and the painting which are left unsaid or just hinted at.
In the poem, for example, notice

– what the painter says and how 'his lady of the afternoons' reacts
– what the people are doing outside.

In the painting, consider

– the woman's pose and dress
– the furnishings of the room.

As a class

Finally, *concentrate on the painting*. Hear the poem read aloud. It needs to be read slowly so that you can follow the poet's thoughts as you (and he) look at the details of the painting.

2 'The Problem of Chains'

PAOLO UCCELLO • *St George and the Dragon*

MARTYN CRUCEFIX • *George and the Dragon*

U. A. FANTHORPE • *Not My Best Side*

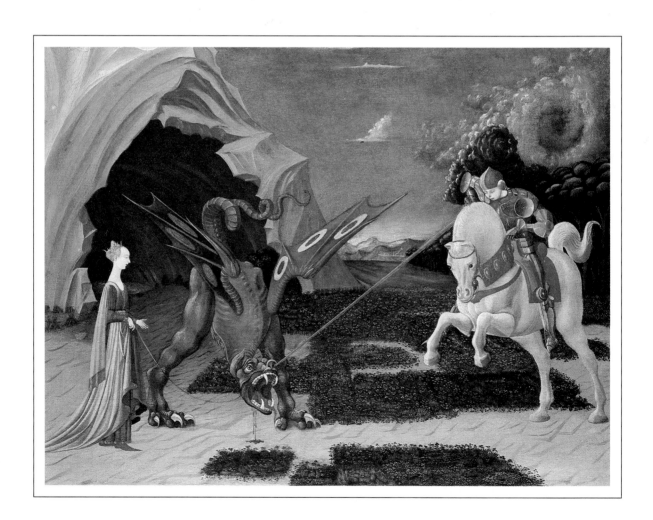

St George has been recognised as the patron saint of England from the days of Edward III in the thirteenth century. The origins of his connection with the dragon are obscure; the dragon is now generally recognised as symbolising the powers of evil.

Uccello's painting dates from the second half of the fifteenth century. Here we see St George in shining armour and mounted on a prancing white horse before a dragon's cave. He is using a lance to spear the winged dragon who is attached to the lady by a fine gold chain.

In groups

- Talk about what is going on in the picture and the way in which the different characters are portrayed. You may think there are some curiosities about the rescue of this princess.
- What might St George and the princess be thinking? Make up a few sentences about each in which you try to capture their thoughts and feelings.

Martyn Crucefix's poem below poses other questions about the painting. Hear it read aloud and ask yourself what you make of the relationship between the princess and the dragon; the fog massing behind St George; the shape and dominance of the black cave.

— *George and the Dragon* —

A boyish George, arrayed in gleaming plate,
lunges forward with a lance and white rocking-horse.
The dragon's head dips in sympathy, bleeds
over the ground, on tousled patches of grass.

But she presents the beast with her palm out-
stretched as if a harmless pet pulled at the chain.
Is she deceived? Or is that fog behind
brave George, the black cave's echo, evil unseen?

Martyn Crucefix

- List any other points or puzzles that you notice about the painting and discuss these before moving on to the second poem.

U. A. Fanthorpe's poem, *Not My Best Side*, is also based on the painting.

- Work in threes and prepare a live reading of the poem for performance to another group or to the rest of the class. Decide whose voice sounds best for each of the three different characters, thinking carefully about what would be an appropriate tone for each to adopt.

— *Not My Best Side* —

(Uccello: *S. George and the Dragon,* The National Gallery)

I
Not my best side, I'm afraid.
The artist didn't give me a chance to
Pose properly, and as you can see,
Poor chap, he had this obsession with
Triangles, so he left off two of my
Feet. I didn't comment at the time
(What, after all, are two feet
To a monster?) but afterwards
I was sorry for the bad publicity.
Why, I said to myself, should my conqueror
Be so ostentatiously beardless, and ride
A horse with a deformed neck and square hoofs?
Why should my victim be so
Unattractive as to be inedible,
And why should she have me literally
On a string? I don't mind dying
Ritually, since I always rise again,
But I should have liked a little more blood
To show they were taking me seriously.

II
It's hard for a girl to be sure if
She wants to be rescued. I mean, I quite
Took to the dragon. It's nice to be
Liked, if you know what I mean. He was
So nicely physical, with his claws
And lovely green skin, and that sexy tail,
And the way he looked at me,
He made me feel he was all ready to
Eat me. And any girl enjoys that.
So when this boy turned up, wearing machinery,
On a really *dangerous* horse, to be honest,
I didn't much fancy him. I mean,
What was he like underneath the hardware?
He might have acne, blackheads or even
Bad breath for all I could tell, but the dragon –
Well, you could see all his equipment
At a glance. Still, what could I do?
The dragon got himself beaten by the boy,
And a girl's got to think of her future.

III
I have diplomas in Dragon
Management and Virgin Reclamation.
My horse is the latest model, with
Automatic transmission and built-in
Obsolescence. My spear is custom-built,
And my prototype armour
Still on the secret list. You can't
Do better than me at the moment.
I'm qualified and equipped to the
Eyebrow. So why be difficult?
Don't you want to be killed and/or rescued
In the most contemporary way? Don't
You want to carry out the roles
That sociology and myth have designed for you?
Don't you realize that, by being choosy,
You are endangering job-prospects
In the spear- and horse-building industries?
What, in any case, does it matter what
You want? You're in my way.

U. A. Fanthorpe

On your own

- Ursula Fanthorpe tells of how a ten year old girl once asked her why she had missed out the fourth character. Compose a new fourth verse from the horse's point of view.

EDWARD BURNE-JONES • *The Rescue of Andromeda*

CONNIE ROSEN • *Andromeda*

In ancient Greek myth, Andromeda was the daughter of King Cepheus of Joppa in Ethiopia and of Cassiopea. The mother boasted to the sea god, Poseidon, that her daughter Andromeda was more beautiful than Poseidon's daughters. Poseidon was so incensed that he sent a dragon-like sea monster which ravaged the country and could only be satisfied by the sacrifice of Andromeda. She was therefore chained to a rock on the sea coast and exposed to await the monster's fury.

Perseus, the son of Zeus – king of the gods – and Danae, was returning from slaying Medusa, the Gorgon whose head turned all who looked on it to stone. Having cut off Medusa's head (and having first thoughtfully

obtained Cepheus' consent to his marrying Andromeda if he could save her), Perseus successfully slew the monster and was thus able to claim his prize.

EDWARD BURNE-
JONES (British)
*The Rescue of
Andromeda, c.1880.
Southampton City Art
Gallery*

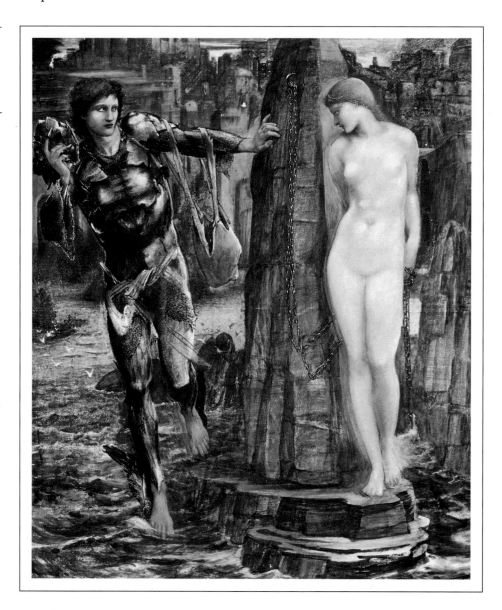

On your own

● Jot down your thoughts about the following:

(i) The appearance of Perseus – you might like to consider his face, his clothing, his stance.

(ii) The appearance of Andromeda – you might like to consider her
face, her lack of clothing, her stance.
(iii) Consider the appearance of the rock and the chains.

In pairs or small groups

- Share your thoughts with those of a partner or with those of others in
your group.

Now read the poem *Andromeda* by Connie Rosen.

— *Andromeda* —

Consider the problem of chains.
It would appear that Andromeda
Tied to the rock
Waited for our hero to arrive
To cut them.
But sea air is bad for chains
In time they'd rusted badly.
Broken links, small heaps of red dust
Lay around
Unobserved
That is to say, deliberately unobserved
Until
In spite of innumerable
Surreptitious efforts to piece them together
The facts were unavoidable
They'd crumbled, vanished
Outlived their purpose.
But tendencies for chain-making
Continue to compel.
It was no great problem for one
Accustomed to such matters
To replace the old set with a new
But different . . .
Man-held not rock-held

Chains, chain-making and chain-makers
Are likely to be much affected
By the differences between men and rocks.

Connie Rosen

In pairs or small groups

- Consider the problem of chains. What does Connie Rosen suggest when she writes 'deliberately unobserved'; 'outlived their purpose'; 'But tendencies for chain-making continue to compel'?
- What was the nature of the new set of chains?

On your own

- Write a letter to the artist – 'Dear Sir Edward . . .' – saying why you approve/disapprove, like/dislike his painting and, in particular, the depiction of male and female roles as portrayed by Andromeda and Perseus.

You may be interested to know that the painting is what is known technically as a 'cartoon': that is the final, full-size drawing of a series of preparatory sketches, in which the artist includes all the information he or she has worked out in the smaller studies and wants to remember for the finished painting. This is why some of the detail, for example, Perseus' sword, is only lightly sketched in. The artist fully completed only four of what was to be a series of ten paintings although all ten exist in this cartoon form. If you wish to know more, write to Southampton City Art Gallery (see p. 125).

THOMAS GOTCH · *Alleluia*

SYLVIA KANTARIS · *Thank Heaven for Little Girls*

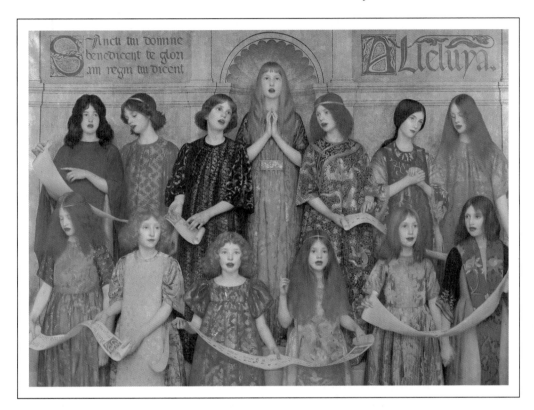

On your own

- Study the painting carefully. Look especially at the expressions on the girls' faces and at their hand movements.
- Select *one* of the thirteen and try to read what might be going on 'behind her eyes'. Invent a few sentences about what she could be thinking to herself as she sings her 'alleluias' in the choir.

As a group

- Share your imagined 'thought-tracks' with the rest of the class. Try to ensure you account for all thirteen choristers.

THOMAS GOTCH
(British)
Alleluia, c.1896. The Tate Gallery, London

Now hear Sylvia Kantaris' poem, *Thank Heaven for Little Girls*, read aloud.

— *Thank Heaven for Little Girls* —

Six little girls in front like stained-glass
saints in stiff Pre-Raphaelite brocade
have lost their place already in the two-line text.
A budding Thomasina on the far left
entertains grave doubts about the words.
The youngest needs to be excused *in media res*

You'd think the bigger girls in bulging smocks
would make a point of looking jubilant
but two (extreme left) find the text abhorrent.
I suspect the one who didn't even bother
to change out of her plain old burnt sienna
of chanting 'Rhubarb, rhubarb' *sotto voce*. Alleluia.

It's no wonder that the dark girl with the sad face
(right) seems confused about her function here –
posed for a Pietà, out of context –
unlike the elevated centrepiece,
ecstatic in the role of Christ. Her gender
gives a double edge of satire to the picture.

She is the only one of age who isn't pregnant yet,
though clothed in green and gold like Mother Earth
amongst these fidgety disciples who were not designed
to worship either gods or goddesses.
Alleluia therefore, and thank Heaven that most girls
make short shrift of apostolic attitudes.

Sylvia Kantaris

In pairs or small groups

- Discuss the way Sylvia Kantaris has characterised each of the girls she concentrates on in her poem.
- What do you make of the last two lines of the poem?
- The painting is a tableau. Using the 'thought-tracks' that the class invented, make up a verbal tableau – a poem in perhaps ten or a dozen short verses (each separated by an 'alleluia'?) which describes in words how you see the characters in the painting and what you imagine them to be thinking. This could be an individual piece of writing or a group/class poem.

3 Vincent: 'Poems Without Words'

VINCENT VAN GOGH • (1853–1890)

This section, as with the later one on Bruegel, introduces paintings by a single artist and invites you to study the pictures and respond to poems they have inspired.

1 Wheatfield Under Threatening Skies With Crows (Cornfield with Crows)

In pairs

● Look carefully at the picture on pages 40–41 and discuss what you see. Think particularly about the mood of the picture: the way the paint is handled, the effect of the colours, the portrayal of the track, the cornfield and the crows.

Now read through the following poems. All but the first were written by students at school.

— *Van Gogh, July 1890* —

The sky
incinerates
blue-fumed
& black
crow-scrawled

over corn-yellows
nerved with
an unrelieved
charge of
crackling static.

B. C. Leale

VINCENT VAN
GOGH (Dutch/
Flemish)
*Wheatfield Under
Threatening Skies With
Crows (Cornfield with
Crows), 1890. The
Rijksmuseum,
Amsterdam*

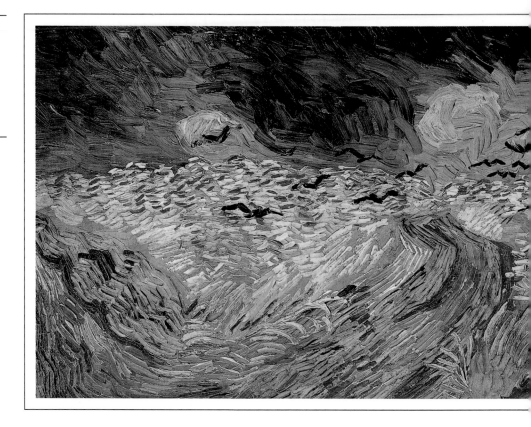

— *Van Gogh, Cornfield with Crows* —

The dirt-track uncoils and smears the gold,
Plunges tunnel-like and is lost.
Cornfields of Arles smash at the sky,
The crust of the earth buckles,
Slowly, painfully, like an animal.
No wind yet the sky whirls in hurricanes—
Blue, staining like blood
Gathering.
Midday meets with night in the sky.
Crows watch for the cracks.
The rocks sway under the roaring corn
As if hearing through a skin of sunstroke.
Drifting
Mad and blaring in the oils of his eyes,
The picture howls with fruitfulness.

James O. Taylor

— *Just Passing* —

A scene
Seen
Is captured
In a painter's
Head
Is captured
Frozen and colourful

Mr Gogh
Shot his head
To fragments
But the scene
Seen
Remains.

Francis Barker

— *The Artist, Arles 1890* —

Yellow yellow
Watch the yellow always,
Fascinated, from the corner of your eye.
Its terrible intensity has sting
To bleach the brain, to take the skin
From off your inner eye. To drive you back
Against a buckled wall that echoes yellow, yellow
Pain. You cannot let it from your mind.

Colin Rowbotham

In groups

- Prepare readings of the poems. Think about whether the poems might best be shared among several voices, and about the tone and pace of your reading.
- After hearing some interpretations aloud, decide which poem has most appeal for you.
- This is the last picture Vincent painted before he killed himself – in fact, by shooting himself in the chest. 'I shot myself . . . I only hope I haven't botched it,' he said to Theo, his brother, before dying in his arms two days later.
- Does this piece of information confirm or alter your reading of the picture?

2 *Landscape with Cypresses Near Arles*

In pairs or small groups

- After you have looked at Van Gogh's painting, *Cornfield with Crows*, on p. 40 and discussed the four poems about it, look at the painting opposite – *Landscape with Cypresses Near Arles*.
- Although this is a landscape, there seems to be a sense of movement about the painting. How does Van Gogh achieve this effect? Think about the way he handles the painting of the separate parts – the sky, the cypresses, the hills, the grass.
- Now put these separate elements back together again and ask yourself what the combined effect of these things is upon the viewer. What feelings do you think Van Gogh may have hoped to convey?

E. H. Gombrich wrote

> . . . Van Gogh used the individual brush-strokes not only to break up the colour but to convey his own excitement. In one of his letters from Arles he describes his state of inspiration when 'the emotions are sometimes so strong that one works without being aware of working . . . and the strokes come with a sequence and coherence like words in a speech or letter.' The comparison could not be clearer. In such moments he painted as other men write. Just as the form of the writing in a letter, the traces left by the pen on the paper, impart something of the gestures of the writer, so that we feel instinctively when a letter is written under great stress of emotion – so the brush-strokes of Van Gogh tell us something of the state of his mind.
> (from *The Story of Art*, by E. H. Gombrich)

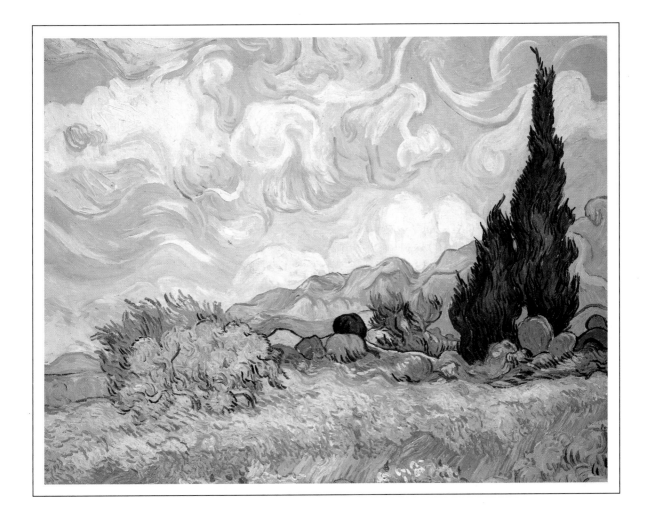

VINCENT VAN
GOGH (Dutch/
Flemish)
*Landscape with Cypresses
Near Arles, 1888. The
National Gallery, London*

When you have looked at both *Cornfield with Crows* and *Landscape with
Cypresses*, read Phoebe Hesketh's poem, *Vincent*, which follows.

— *Vincent* —

Blue he strove for – pure cobalt
of burning skies
till light inflamed him.
Slashing the red
poppies through writhing corn
he gashed the field,
grabbed yellow by the hair
dragging roots sun-upward.

'O, torment of sun-yellow tormentil* – * small flowering plant
fiery blood of the sun
sticks to my knife;
I'm twisted like a flag around a pole
confused by coloured voices in the wind.

Colour is naked – underneath the skin
I grope back to the essence
spill my blood
yet cannot win a woman's love.
Cornfields' burnt sienna, stubble-sharp,
rasps – I walk on broken glass.

Cypress straining against the gale
I am deafened by God's word.
Yet listen, listen –
green tongues sing;
I paint myself out loud.
I paint the wind in sibilant grasses –
green pastures framed beyond a psalmist's dream.

Again the whirlwind;
bladed words flung wide,
and the wound that never heals bleeds on –
crimson seeds congeal to black
cracking my skull.
Sunflowers explode behind my eyes
and I gaze unblinded on the naked sun.'

Phoebe Hesketh

Writing about the origins of her poem, Phoebe Hesketh comments:

I was, in fact, thinking primarily about Van Gogh's lavish use of
colour and of his passionate knife-splashing of it onto canvas. When
writing the poem images of his *several* landscapes came to mind: yes –
Cornfield with Crows and *Landscape with Cypresses Near Arles* in
particular.

In pairs or small groups

● After reading the poem, look again at the two pictures, *Cornfield with Crows* (p. 40) and *Landscape with Cypresses* (p. 43). Does reading the poem help your reading of the pictures and your understanding of the painter's mind?

Now read Phoebe Hesketh's second poem, *Letter to Vincent*, which refers not to a picture that he has painted but to one that he never attempted.

— *Letter to Vincent* —

You never painted this picture, Vincent –
sunflowers pressed white on window-glass
by fingers of ice
beyond summer skills of brush and knife.
No blood in these petals
shrinking under the sun.
No gold for our looking,
only evidence of cold, unhuman magic
that even you,
painter of poems without words,
have no colours for.

Phoebe Hesketh

In pairs or small groups

● Van Gogh never painted frost flowers like those Phoebe Hesketh writes of. By drawing our attention to something he never painted, what does she tell us about the nature of the things he *did* paint?

On your own

● Writing about the origins of her poem, Phoebe Hesketh comments it was

> as a result of taking the creative writing group of sixth formers at ———— school. . . . I gave them a large book of Van Gogh's paintings. One girl began a poem with the good line 'You never painted this picture, Vincent'. I thought much about this, then wrote my own poem.

Towards the end of her poem, Phoebe Hesketh calls Van Gogh a 'painter of poems without words'. In this poem and the earlier one,

Vincent, she herself could perhaps be seen as a 'word painter'. Try 'word painting' yourself and either:

– write your own poem in response to one of the Van Gogh pictures in this book *or*
– find another Van Gogh picture that appeals to you from an art book or on a postcard, and create your own 'word painting'. Remember E.H. Gombrich's suggestion that Van Gogh painted as other people write: your aim here might be to try to reverse the process and to write as Van Gogh painted.

Note: Further poems about Van Gogh's paintings can be found in *Dear Vincent* by Anna Adams (see p. 125).

3 *Starry Night, St Rémy*

VINCENT VAN GOGH (Dutch/ Flemish) *The Starry Night (St Rémy, 1889). Collection, Museum of Modern Art, New York*

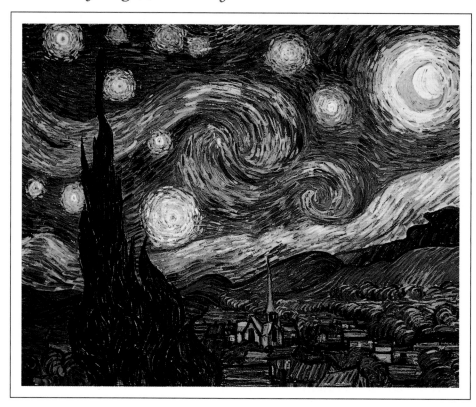

On your own

- Concentrate your attention on Van Gogh's painting, *Starry Night, St Rémy*, letting your eye take in the details of the landscape and the sky.
- Place a sheet of paper alongside the picture and jot down your thoughts or impressions. If you find it helps, you can sketch an outline of the picture in the centre of your page as we have done and jot your thoughts around it. We have suggested some questions: you may well have others.

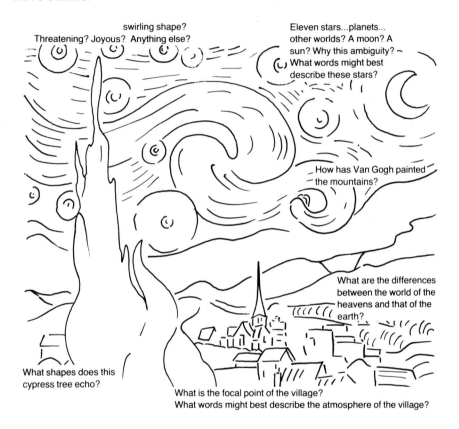

swirling shape?
Threatening? Joyous? Anything else?

Eleven stars...planets... other worlds? A moon? A sun? Why this ambiguity? What words might best describe these stars?

How has Van Gogh painted the mountains?

What are the differences between the world of the heavens and that of the earth?

What shapes does this cypress tree echo?

What is the focal point of the village?
What words might best describe the atmosphere of the village?

In pairs or small groups

- When you have jotted down your thoughts, share them and any unanswered questions you may have with the rest of the class.
- According to one of these ancient myths, Eurynome, who was the Goddess of All Things, laid the Universal Egg. At her bidding, Ophion, the great Serpent who fathered the Egg, coiled seven times about it until it hatched and split in two. Out tumbled all things that exist: her children; the sun, moon, planets, stars and the earth with its mountains and rivers, its trees, herbs and living creatures.

Other ancient stories tell of how the end of the universe will come as the stars are devoured by a great serpent. Yet others tell of how children may be born from the eye of a god. With these stories in mind, now hear the poem read aloud.
- Who do you think is the 'I' of the poem?

— *The Starry Night* —

That does not keep me from having a terrible need of – shall I say
the word – religion. Then I go out at night to paint the stars.
Vincent Van Gogh in a letter to his brother

The town does not exist
except where one black-haired tree slips
up like a drowned woman into the hot sky.
The town is silent. The night boils with eleven stars.
Oh starry starry night! This is how
I want to die.

It moves. They are all alive.
Even the moon bulges in its orange irons
to push children, like a god, from its eye.
The old unseen serpent swallows up the stars.
Oh starry starry night! This is how
I want to die:

into that rushing beast of the night,
sucked up by that great dragon, to split
from my life with no flag,
no belly,
no cry.

Anne Sexton

In pairs or small groups

- Does Van Gogh's comment in his letter to his brother help to explain what he expresses in his painting of the stars?
- Anne Sexton's poem focuses particularly on the movement of the heavens. List all the words in the poem suggesting movement and discuss why she chooses them.
- In her poem, Anne Sexton matches Van Gogh's images in paint with her own in words. When she contemplates *Starry Night* she is reminded of a rich treasury of ancient mythic stories about the gods and the beginnings of the universe. What is it about the painting that moves her to think in this way?

4 Visionaries

WILLIAM BLAKE • *The Sick Rose* and *The Tyger*

No other poet has been so involved in creating a book of poems and paintings as William Blake was when making *Songs of Innocence and Experience*, from which these two poems are taken. Here, the double vision became a single one. Blake was both poet and artist. He was not satisfied to see his poems only as written texts. He conceived each poem-picture as an artistic unity.

Blake developed a new method of printing which enabled him to create his illuminated books by etching *both* the poem and the design in relief on a copperplate. It was very slow and labour-intensive but it enabled him to present his poems to the public as part of a picture so that the two arts complemented each other.

> Blake's method demanded the laborious transfer of a written text to an etched copperplate, from which an impression could be printed in ink of any colour that he chose. The text would then be combined on the copper with illustrations or simple decorations harmonizing with the script, after which the whole print was coloured with pen or paint-brush, varied as he pleased in each copy that he made.
>
> (Geoffrey Keynes)

Blake's method meant that each copy of his book was a unique creation. Not only did he use a variety of inks (blue, green, brown or black) when printing, but the watercolour illumination of each copy had its own particular colours. Some appear light, almost transparent; other copies are richly decorated in glowing colours.

Blake's *Songs of Innocence and Experience* were, literally, all his own work. The writing, engraving, printing and colouring – even the grinding and mixing of the pigments to his own recipe – were done by Blake himself. The binding was done by his wife. On pp. 50–51 are two examples of Blake's poem-pictures. If you want to know more, there is a paperback edition of the *Songs*, with an introduction and commentary by Sir Geoffrey Keynes, published by Oxford University Press.

What do you make of the poems and the paintings?

WILLIAM BLAKE
(British)
The Sick Rose, c.1790.
The British Museum,
London

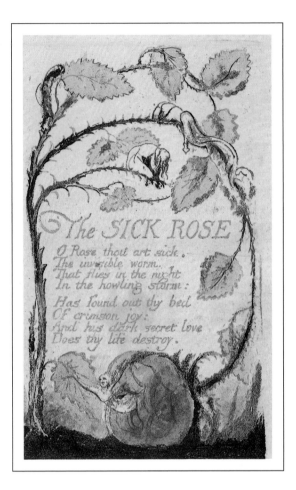

On your own

- Copy out the poem above on a separate sheet of paper. (Don't pay too much attention to the punctuation; Blake's use of it is eccentric.) Thoughts and feelings may well start to gather around the words as you write them out.
- Make a note of the overall feeling or idea that the poem gives you.

In pairs

- Concentrate on the details of the picture.
- What do you make of the rose at the bottom of the design, the caterpillar (top left), the attitudes of the two figures, and the thorns along the stems?
- When you have discussed both the poem and the picture with your partner, compare ideas with the rest of the class.

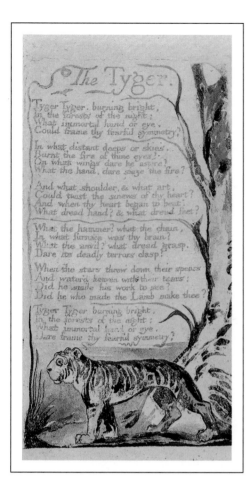

WILLIAM BLAKE
(British)
The Tyger, c.1790. The
British Museum, London

Look at the tiger in this painting. Geoffrey Keynes says that 'in some copies of the book the animal is a ferocious carnivore painted in lurid colours. In others it appears to smile as if it were a tame cat.'

- What sort of image does Blake give us here?

Hear the poem read aloud. The poem is a series of questions, none of which is answered.

- Read it through again to yourself and jot down what *you* think Blake might be questioning.
- Share your ideas with the rest of the class.
- The meaning of the poem is elusive. It is carried by the sounds, rhythms and associations of words which cannot be paraphrased. It is a poem where you may *feel* a meaning but may not be able to explain it! Don't leave the poem without hearing it read aloud again.

SAMUEL PALMER • *Coming from Evening Church*

CHARLES CAUSLEY • *Samuel Palmer's 'Coming from Evening Church'*

SAMUEL PALMER
(British)
*Coming from Evening
Church, 1830. The Tate
Gallery, London*

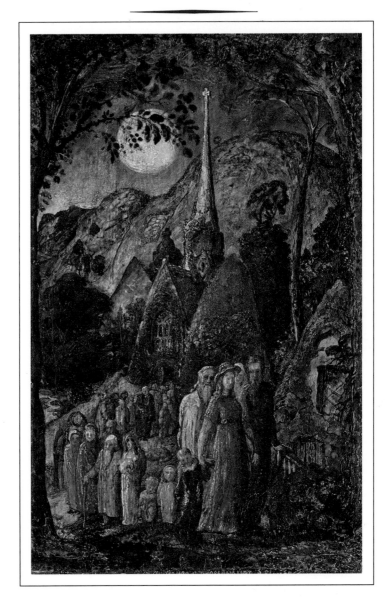

On your own

● Concentrate your attention on Samuel Palmer's painting, *Coming from Evening Church*, letting your eye take in every detail of the buildings,

the people, the natural world, the colours, and the shapes.
- Place a sheet of paper alongside the picture and jot down any thoughts or impressions. If you find it helps, you can sketch the outline of the picture in the centre of your page as we have done and write your thoughts and questions around it.

The *light* is a mixture of the dying sun and the rising moon. Notice how it touches the details of the painting and the effect it has.

Think about the main *shapes* — the trees, the hills, the church, the cottage and the spire.

There is a lot of *natural detail* (trees, ivy, etc.). List what you see and think about why such details are included. Don't miss the sheep penned on the hill to the left of the spire.

Look carefully at the *people*. Do the dress and appearance of the congregation suggest anything other than people of 1830 (the date of the picture)?

Think about the *colours* and the atmosphere they help to create.

- When you have jotted down your own thoughts, share them with a partner or in a small group.
- How do you think Samuel Palmer saw the Church in the life of the small village community?

On your own

- Write a paragraph which captures the atmosphere of Palmer's idyllic world.

Listen to Charles Causley's poem, *Samuel Palmer's 'Coming from Evening Church'*, being read aloud after you have looked at and discussed Palmer's picture.

— *Samuel Palmer's* —
'Coming from Evening Church'

The heaven-reflecting, usual moon
Scarred by thin branches, flows between
The simple sky, its light half-gone,
The evening hills of risen green.
Safely below the mountain crest
A little clench of sheep holds fast.
The lean spire hovers like a mast
Over its hulk of leaves and moss
And those who, locked within a dream,
Make between church and cot their way
Beside the secret-springing stream
That turns towards an unknown sea;
And there is neither night nor day,
Sorrow nor pain, eternally.

Charles Causley

In pairs

● Do you feel that Charles Causley has successfully captured the
atmosphere of Palmer's picture? Jot down a few words or phrases
from the poem which seem to you to catch the feeling of the painting.

Even as a child, Palmer was an able painter, having exhibited – and
successfully sold – two of his paintings at the British Institute on his
fourteenth birthday. When he was 21 he met and was greatly influenced
by the visionary artist and poet, William Blake. Blake is perhaps best
known to most people today for his poem *Jerusalem* which has long been
a popular hymn. You may find an echo of some of the lines from
Jerusalem in Palmer's painting:

And did those feet in ancient time
 Walk upon England's mountain's green?
And was the holy Lamb of God
 On England's pleasant pastures seen?

And did the Countenance Divine
 Shine forth upon our clouded hills?
And was Jerusalem builded here
 Among these dark Satanic Mills? . . .

Palmer generally produced small-scale, detailed landscapes with human
figures. Intense religious feelings run through all his work and are
expressed through a oneness with the natural world which suggests that,
for him, Eden was never lost.

SAMUEL PALMER ◆ *Late Twilight*

SAMUEL PALMER ◆ *Shoreham: Twilight Time*

Palmer was, in fact, a minor poet in his own right. His description of the little village of Shoreham in Kent at the close of day in his poem, *Shoreham: Twilight Time*, attempts to capture in words feelings very similar to those that gave rise to his painting, *Coming from Evening Church*. For Palmer, the moon was a symbol of love and innocence 'not only,' as he wrote to his friend Linnell, 'thrilling the optic nerve but shedding a mild, a grateful, an unearthly lustre into the inmost spirits and seeming the interchanging twilight of that peaceful country where there is no sorrow and no night.' A similar feeling pervades his drawing, *Late Twilight*, which is here paired with Palmer's poem.

- Look at Palmer's pen and brush drawing, *Late Twilight*, and then hear the poem read aloud. What similarities do you detect between poem and picture?

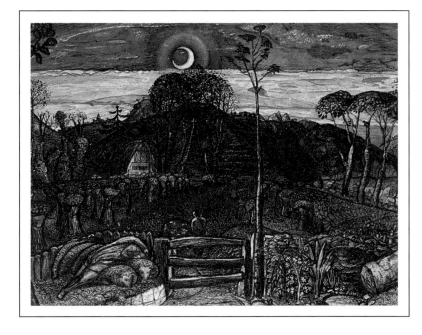

SAMUEL PALMER
(British)
Late Twilight. The Ashmolean Museum, Oxford

— *Shoreham: Twilight Time* —

And now the trembling light
Glimmers behind the little hills and corn,
Ling'ring as loth to part; yet part thou must
And though than open day far pleasing more
(Ere yet the fields and pearlèd cups of flowers
 Twinkle in the parting light;)
Thee night shall hide, sweet visionary gleam
That softly lookest through the rising dew;
 Till all like silver bright,
 The faithful witness, pure and white,
 Shall look o'er yonder grassy hill,
 At this village, safe and still.
 All is safe and all is still,
 Save what noise the watch-dog makes
 Or the shrill cock the silence breaks.
 Now and then –
 And now and then –
 Hark! Once again,
 The wether's bell
 To us doth tell
Some little stirring in the fold.
Methinks the ling'ring dying ray
Of twilight time, doth seem more fair,
And lights the soul up more than day
When wide-spread sultry sunshines are:
Yet all is right and all most fair,
For thou, dear God, has formèd all;
Thou deckest every little flower,
Thou girdest every planet ball,
And mark'st when sparrows fall.

Samuel Palmer

5 Landscapes

JOHN CONSTABLE • *The Haywain*

JOHN CONSTABLE • *Willy Lott's House Near Flatford Mill*

B. C. LEALE • *Sketch by Constable*

It has been suggested that John Constable's oil sketch of *Willy Lott's House* (p. 58) was a rapid, on-the-spot study which was later used by the artist as the source of the lefthand side of his much more famous picture, *The Haywain*, which he painted in his London studio several years later over a period of about five months.

JOHN CONSTABLE
(British)
The Haywain, 1821. The National Gallery, London

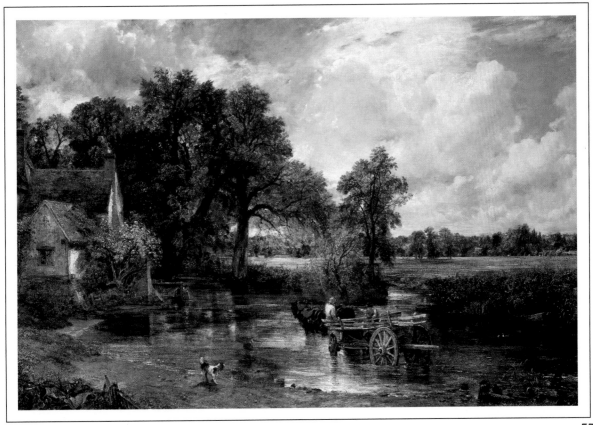

In pairs

- Look carefully at the early sketch below.
- Talk about the details of what you see. Look especially at where the light falls in the picture.
- How would you describe the dog and its movement?

JOHN CONSTABLE
(British)
*Willy Lott's House Near
Flatford Mill, c.1810.
Victoria and Albert
Museum, London*

- Now look at the later, finished picture. What changes have taken place on its lefthand side between this and the original sketch?
- How does its atmosphere differ from that of the sketch?

Listen to the poem being read aloud.

— *Sketch by Constable* —

The dog knows it's an early draft. He's
full of destinations and joy as he
rounds the first bend from the house –
his shadow sharp, vibrant. Even the
path's edge is of frisky earth.

About five years later he's finished.
His short run by the water's edge completed and
he's famous. With muted shadow he looks up
to the men in a motionless hay-wain.

B. C. Leale

- Discuss the changes that the poet sees between sketch and final painting. Does he focus on the same things as you? Has the dog been spoiled by fame? Which dog do you prefer?

On your own

- If you share something of Constable's feeling for this tranquil world, perhaps you could write your own poem from the point of view of one of the characters in the picture: the man fishing from the far bank; the woman kneeling at the water's edge near the cottage; one of the men in the haywain as it fords the stream; or even the dog. They are all transfixed and timeless. What do they see? What do they feel?

CLAUDE MONET • *Break-up of the Ice Near Lavacourt*

U. A. FANTHORPE • *La Débâcle. Temps Gris*

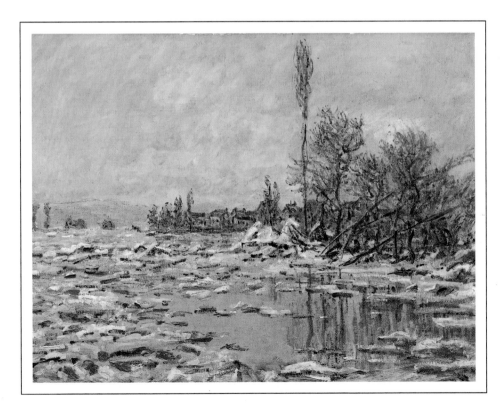

CLAUDE MONET
(French)
Break-up of the Ice Near Lavacourt, 1880.
Calouste Gulbenkian
Foundation, Lisbon

Look carefully at Monet's painting of thawing ice. It shows a scene on the River Seine near the town of Lavacourt in northern France.

On your own

- There is little movement; there are no people. Everything is painted to capture the atmosphere of the ice loosening its grip.
- List, say, the six aspects of the scene that you think are the most important in achieving this feeling in the picture (the ice floes, the fallen trees, etc.). Concentrate on each of these details in turn and jot down a few words, phrases or comparisons to describe what you see.

In pairs or groups

- Compare notes and see what sort of word-pictures you have built up.
- In particular, what can you say about Monet's use of *colour* and about how he has created the wintry *light*?

Now, hear U. A. Fanthorpe's poem read aloud.

— *La Débâcle. Temps Gris* —

Seine. Facing south. Mid-day.
No sun. Cloud heavy over Lavacourt,
No boat, no body. Water, ice, snow,
Houses, trees, hills, cloud, sky.

This picture means nothing
More than it shows. The tree standing alone
Is not me, though I understand
Why you might think so. Wrongly.

Not a thing here means
Anything but that it is here,
Now. I am the witness, bound to set down
What I see. This is what I see,

Watch. Begin with the water.
It is undisturbed. In it flower stilly
The crooked refractions of poplars.
The poplars grow up from underwater,

The poplars grow up from above water.
Ice and snow come between tree and reflection.
In this weather reflection does not grow into tree.
Ice bars it. Begin again with the water.

There is one ice-free patch. Here
The reflections are. Beyond, brash ice
That tomorrow will be free water.
I painted the water first, lying under.

Ice slabs jolt to edged poses:
Planks, tents, scrubbing brushes, gables,
Lobsters, slices of cake. Light on ice
Shines green, blue, yellow, red,

Rashers of colour run along
The slab-sides. Water and film and ice
Mirror the hummocky pink-grey cloud.
This is the moment. I have trapped it.

Moving did happen. Poplars
Were felled by snow; these can be seen.
An ice-clamped-solid reach can be deduced
From the gashed floes. People

Live in the houses, perhaps. I will not say.
I record what I see: the silent
Unclenching of the still-clenched river.
The Break-up of the Ice. The weather, grey.

U. A. Fanthorpe

As a class or group

- Discuss what are the important aspects of the scene to this writer.
 What would her list of, say, six details be?
- Think about the viewpoint the poet adopts and her use of notes and
 many short sentences. What reasons may she have had for writing in
 this way?

On your own

- You could use your notes above to write your own short poem about
 the painting.
- You could write about U. A. Fanthorpe's poem, saying what you
 like/dislike about her response to the painting.

6 Pictures From Poems

Poems that inspire artists to paint pictures are less common than pictures that inspire poets to write verse. Although there are many examples of paintings that have been suggested by Biblical episodes or by scenes from Shakespeare's plays, only relatively rarely is the single poem the inspiration for a painting intended to stand on its own: more frequently the pictures that spring from a single poem were commissioned to accompany it as book illustrations. In some cases, such book illustrations have a strength and a public appeal that means they stand in their own right and not as merely decorative material, subsidiary to the text.

Tennyson's poem, *The Lady of Shalott*, was one which caught the popular imagination in the mid-nineteenth century when it was first published, and it was the inspiration for several paintings. We have included two here. First Holman Hunt's picture which depicts the fatal moment when the Lady of Shalott, weaving her tapestry, sees the reflection of Sir Lancelot in the mirror and looks out of the forbidden window at 'the world outside', thus breaking her vow. Secondly, John William Waterhouse's painting which shows a later scene in the story as she floats down the river.

— *The Lady of Shalott* —

Part I

On either side the river lie
Long fields of barley and of rye,
That clothe the wold and meet the sky:
And thro' the field the road runs by
 To many-towered Camelot;
And up and down the people go,
Gazing where the lilies blow
Round an island there below,
 The island of Shalott.

Willows whiten, aspens quiver,
Little breezes dusk and shiver
Thro' the wave that runs for ever
By the island in the river
 Flowing down to Camelot.
Four gray walls and four gray towers,
Overlook a space of flowers,
And the silent isle imbowers
 The Lady of Shalott.

By the margin, willow-veil'd,
Slide the heavy barges trail'd
By slow horses; and unhail'd
The shallop* flitteth silken-sail'd * light open boat
 Skimming down to Camelot:
But who hath seen her wave her hand?
Or at the casement seen her stand?
Or is she known in all the land,
 The Lady of Shalott?

Only reapers, reaping early
In among the bearded barley,
Hear a song that echoes cheerly
From the river winding clearly,
 Down to tower'd Camelot:
And by the moon the reaper weary,
Piling sheaves in uplands airy,
Listening, whispers ''Tis the fairy
 Lady of Shalott.'

Part II

There she weaves by night and day
A magic web* with colours gay. * tapestry
She has heard a whisper say,
A curse is on her if she stay
 To look down to Camelot.
She knows not what the curse may be,
And so she weaveth steadily,
And little other care hath she,
 The Lady of Shalott.

And moving thro' a mirror clear
That hangs before her all the year,
Shadows* of the world appear. * reflections
There she sees the highway near
 Winding down to Camelot:
There the river eddy whirls,
And there the surly village-churls,
And the red cloaks of market girls,
 Pass onward from Shalott.

Sometimes a troop of damsels glad,
An abbot on an ambling pad,
Sometimes a curly shepherd-lad,
Or long-hair'd page in crimson clad,
 Goes by to tower'd Camelot;

And sometimes thro' the mirror blue
The knights come riding two and two:
She hath no loyal knight and true,
 The Lady of Shalott.

But in her web she still delights
To weave the mirror's magic sights,
For often thro' the silent nights
A funeral, with plumes and lights,
 And music, went to Camelot:
Or when the moon was overhead,
Came two young lovers lately wed;
'I am half-sick of shadows,' said
 The Lady of Shalott.

WILLIAM HOLMAN
HUNT (British)
The Lady of Shalott.
Wadsworth Atheneum,
Hartford, Connecticut

Part III

A bow-shot from her bower-eaves,
He rode between the barley-sheaves,
The sun came dazzling thro' the leaves,
And flamed upon the brazen greaves* * leg armour
 Of bold Sir Lancelot.
A redcross knight for ever kneel'd
To a lady in his shield,
That sparkled on the yellow field,
 Beside remote Shalott.

The gemmy bridle glitter'd free,
Like to some branch of stars we see
Hung in the golden Galaxy.
The bridle bells rang merrily
 As he rode down to Camelot:
And from his blazon'd baldric* slung * shoulder belt
A mighty silver bugle hung,
And as he rode his armour rung,
 Beside remote Shalott.

All in the blue unclouded weather
Thick jewell'd shone the saddle-leather,
The helmet and the helmet-feather
Burn'd like one burning flame together,
 As he rode down to Camelot.
As often thro' the purple night,
Below the starry clusters bright,
Some bearded meteor, trailing light,
 Moves over still Shalott.

His broad clear brow in sunlight glow'd;
On burnish'd hooves his war-horse trode;
From underneath his helmet flow'd
His coal-black curls as on he rode,
 As he rode down to Camelot.
From the bank and from the river
He flash'd into the crystal mirror,
'Tirra lirra,' by the river
 Sang Sir Lancelot.

She left the web, she left the loom,
She made three paces thro' the room,
She saw the water-lily bloom,
She saw the helmet and the plume,
 She look'd down to Camelot.
Out flew the web and floated wide;
The mirror crack'd from side to side;
'The curse is come upon me,' cried
 The Lady of Shalott.

Part IV

In the stormy east-wind straining,
The pale yellow woods were waning,
The broad stream in his banks complaining,
Heavily the low sky raining
 Over tower'd Camelot;
Down she came and found a boat
Beneath a willow left afloat,
And round about the prow she wrote
 The Lady of Shalott.

Lying, robed in snowy white
That loosely flew to left and right –
The leaves upon her falling light –
Thro' the noises of the night
 She floated down to Camelot;
And as the boat-head wound along
The willowy hills and fields among,
They heard her singing her last song,
 The Lady of Shalott.

Heard a carol, mournful, holy,
Chanted loudly, chanted lowly,
Till her blood was frozen slowly,
And her eyes were darken'd wholly,
 Turn'd to tower'd Camelot;
For ere she reach'd upon the tide
The first house by the water-side,
Singing in her song she died,
 The Lady of Shalott.

Under tower and balcony,
By garden-wall and gallery,
A gleaming shape she floated by,
A corse between the houses high,
 Silent into Camelot.
Out upon the wharfs they came,
Knight and burgher, lord and dame,
And round the prow they read her name,
 The Lady of Shalott.

And down the river's dim expanse –
Like some bold seër in a trance,
Seeing all his own mischance –
With a glassy countenance
 Did she look to Camelot.

And at the closing of the day
She loosed the chain and down she lay;
The broad stream bore her far away,
 The Lady of Shalott.

Who is this? and what is here?
And in the lighted palace near
Died the sound of royal cheer;
And they cross'd themselves for fear,
 All the knights at Camelot:
But Lancelot mused a little space;
He said, 'She has a lovely face;
God in his mercy lend her grace,
 The Lady of Shalott.'

 Alfred, Lord Tennyson

In pairs

- Try to establish what happens in each Part of the story.

 In Part I:
 Talk about when and where the story is set and about what we know
 of the Lady.
 In Part II:
 Discuss what prevents the Lady from looking from her window and
 how nonetheless she manages to see the outside world. How does she
 spend her time?
 In Part III:
 What happens when Lancelot comes on the scene?
 In Part IV:
 How does the Lady die?

- What images does the poem leave in your mind? Without looking back
 at the words on the page or forward to the picture, try to describe the
 world of the poem.

Now look carefully at John William Waterhouse's painting of The Lady of
Shalott.

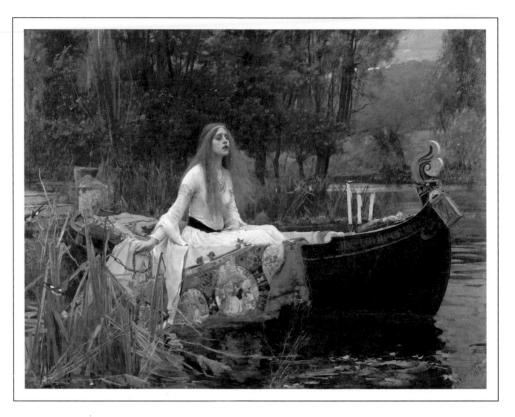

JOHN WILLIAM
WATERHOUSE
(British)
*The Lady of Shalott,
1888. Tate Gallery,
London*

In pairs or small groups

- Talk about the appearance of the Lady. Look at her dress, her hair, her face.
- Talk about the appearance of the boat. Look at its shape, the curved prow, the figure in the bows and the candles.
- What details can you see embroidered on the rich cloth that drags in the water?
- Although the picture is of something that happened a long way back in time – in King Arthur's Britain – the picture was painted not much more than 100 years ago. What might lead you to believe it was a relatively recent painting?
- Compare the image that Waterhouse presents in his painting with the mental picture you formed when you read the poem.

The poem was first published in 1852 and is based on one of the many stories associated with King Arthur and his court which had become very popular in Victorian England. Tennyson was later to write a much fuller account of the Lady and her love for Lancelot in his longer series of

poems known as *The Idylls of the King*, published in 1859. It differs somewhat from the earlier account which is given in *The Lady of Shalott*. According to the Arthurian legend, the Lady of Shalott was Elaine – 'the lily-maid of Astolat' or, more prosaically, of Guildford in Surrey – who fell in love with the courtly knight, Lancelot, at a royal tournament. He was wounded and Elaine nursed him to health. Lancelot, sadly, had to tell her that he loved somebody else, and left her to return to Arthur's court. Dying of a broken heart, Elaine dictated a farewell letter to Lancelot which she made her father promise to clasp in her dead hand. She directed that her body should be laid in state on a barge and sent to Camelot. At Camelot, Lancelot saw the funeral barge drift slowly down the stream. The body was brought into the presence of King Arthur and the letter read aloud to the court. Arthur, touched by the story of the girl's love, bade Lancelot fulfil her last request and lay her to rest.

SAMUEL TAYLOR COLERIDGE • *The Rime of the Ancient Mariner, Part III*

GUSTAV DORÉ • *The Ship of Death*

Coleridge's lengthy poem, *The Rime of the Ancient Mariner*, was first published in 1798. It tells how an ancient mariner detains one of three young men on their way to a wedding feast and recounts his strange story. His ship was drawn to the South Pole by a storm where it was visited by an albatross which the mariner shot with his cross-bow. For his cruel act, a curse falls on the ship. It is driven north to the tropics where it is becalmed under a remorseless sun and the crew begin to die of thirst. The mariner has the dead albatross hung round his neck by his shipmates as a sign of his guilt. The third part of the poem, which is reprinted below, begins at this stage in the mariner's story.

— *from The Rime of the Ancient Mariner* —

1 'There passed a weary time. Each throat
 Was parched, and glazed each eye.
 A weary time! a weary time!
 How glazed each weary eye,
 When looking westward, I beheld
 A something in the sky.

2 At first it seemed a little speck,
 And then it seemed a mist;
 It moved and moved, and took at last
 A certain shape, I wist.

3 A speck, a mist, a shape, I wist!
 And still it neared and neared:
 As if it dodged a water-sprite,
 It plunged and tacked and veered.

4 With throats unslaked, with black lips baked,
 We could not laugh nor wail;
 Through utter drought all dumb we stood!
 I bit my arm, I sucked the blood,
 And cried, A sail! a sail!

5 With throats unslaked, with black lips baked,
 Agape they heard me call:
 Gramercy! they for joy did grin,
 An all at once their breath drew in,
 As they were drinking all.

6 See! see! (I cried) she tacks no more!
 Hither to work us weal;
 Without a breeze, without a tide,
 She steadies with upright keel!

7 The western wave was all a-flame,
 The day was well-nigh done!
 Almost upon the western wave
 Rested the broad bright Sun;
 When that strange shape drove suddenly
 Betwixt us and the Sun.

8 And straight the Sun was flecked with bars
 (Heaven's Mother send us grace!)
 As if through a dungeon-grate he peered
 With broad and burning face.

9 Alas! (thought I, and my heart beat loud)
 How fast she nears and nears!
 Are those her sails that glance in the Sun,
 Like restless gossameres?

10 Are those her ribs through which the Sun
 Did peer as through a grate?
 And is that Woman all her crew?
 Is that a DEATH? and are there two?
 Is DEATH that Woman's mate?

11 Her lips were red, her looks were free,
Her locks were yellow as gold:
Her skin was white as leprosy,
The Nightmare LIFE-IN-DEATH was she,
Who thicks man's blood with cold.

12 The naked hulk alongside came,
And the twain were casting dice;
'The game is done! I've won, I've won!'
Quoth she, and whistles thrice.

13 The Sun's rim dips; the stars rush out:
At one stride comes the Dark;
With far-heard whisper, o'er the sea,
Off shot the spectre-bark.

14 We listened and looked sideways up!
Fear at my heart, as at a cup,
My life-blood seemed to sip!
The stars were dim, and thick the night,
The steersman's face by his lamp gleamed white;
From the sails the dew did drip –
Till clomb above the eastern bar
The hornéd Moon, with one bright star
Within the nether tip.

15 One after one, by the star-dogged Moon,
Too quick for groan or sigh,
Each turned his face with a ghastly pang,
And cursed me with his eye.

16 Four times fifty living men
(And I heard nor sigh nor groan),
With heavy thump, a lifeless lump,
They dropped down one by one.

17 The souls did from their bodies fly –
They fled to bliss or woe!
And every soul it passed me by,
Like the whiz of my CROSS-BOW!'

Samuel Taylor Coleridge

In pairs

- Try to establish with your partner what happens as this part of the story unfolds. Here are some questions to help you:

 – What do the mariner and his companions think they see approaching in verses 1–4?

 – How do they respond? (verse 5)
 – What aspects of the approaching vessel strike them as strange?
 (verses 6–9)
 – Who are the crew of the vessel? What is their appearance and what
 are they doing? (verses 9–12)
 – What does the Nightmare Life-in-Death win and what is the result
 for the mariner and the crew? (verses 13–17)

● Jot down any references to *colour* and to *light and dark* in these verses.
Discuss how you see in your mind's eye the picture that Coleridge has
created in words.

On your own

● If you were a film director, able to shoot this sequence for the screen,
what would be the main images you would concentrate on? Sketch
out your storyboard as a sequence of cartoon frames with notes:

● You could also arrange a mimed version of this episode from the story
with the mariner and ship's crew on the one hand and the dicing
figures of Death and Life-in-Death on the other. If you decided it was
appropriate, others could read the poem as a background to the
mimed action.

Now look at the illustration for this sequence, *The Ship of Death*, by
Gustav Doré (opposite).

In pairs or small groups

● Talk about how the picture you had in your mind's eye when you read
the verses compares with Doré's picture.
● How would you describe the expression and stance of the two figures?
● What aspects of the vessel itself suggest that it is a ghost ship?

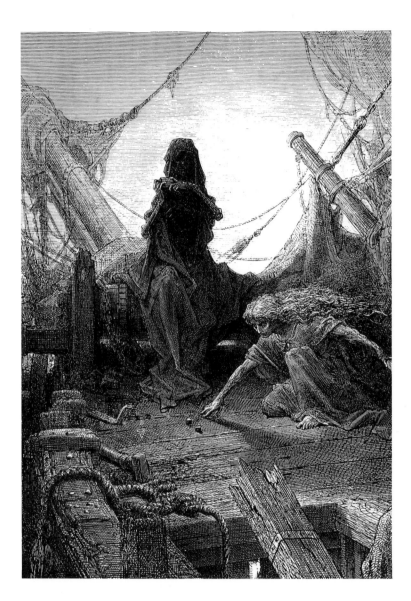

GUSTAV DORÉ
(French)
The Ship of Death, 1875.
The Rime of the Ancient
Mariner, Dover
Publications, Inc., NY

On your own

- Coleridge gives us a description of Life-in-Death in verse 11 but not one of Death himself. Using the ideas in Doré's engraving, write your own verse to the same pattern as Coleridge's verse 11, describing the figure of Death.
- You talked earlier about the colours and the contrasts of light and dark in Coleridge's poem. Doré's black and white engraving cannot quite convey this aspect of the poem. Perhaps you could try to do so by painting your own picture which captures the colours and contrasts you see in Coleridge's poetry.

TED HUGHES · *The Snow-Shoe Hare*

LEONARD BASKIN · *The Snow-Shoe Hare*

— *The Snow-Shoe Hare* —

The Snow-Shoe Hare
Is his own sudden blizzard.

Or he comes, limping after the snowstorm,
A big lost, left-behind snowflake
Crippled with bandages.

White, he is looking for a great whiteness
To hide in.
But the starry night is on his track –

His own dogged shadow
Panics him to right, and left, and backwards,
 and forwards –
Till he skids skittering
Out over the blue ice, meeting the Moon.

He stretches, craning slender
Listening
For the Fox's icicles and the White Owl's slow cloud.

In his popping eyes
The whole crowded heaven struggles softly.

Glassy mountains, breathless, brittle forests
Are frosty aerials
Balanced in his ears.

And his nose bobs wilder
And his hot red heart thuds harder

Tethered so tightly
To his crouching shadow.

Ted Hughes

In pairs or small groups

- Ted Hughes starts his poem 'The Snow-Shoe Hare / Is his own sudden blizzard' and through that image suggests both whiteness and rapid movement. But the creature can move – or rest – in other ways and

Hughes tries to capture several of these. List the different states
through which the hare passes in the rest of the poem.
- Which image(s) of the hare do you like most?

Now look at Leonard Baskin's picture which was painted to accompany
this poem.

- The single painting, unlike the poem with its succession of varied
 images, cannot easily convey the different states through which the
 hare passes. Discuss which aspect(s) of the creature you think
 Leonard Baskin has chosen to concentrate on in his painting.

LEONARD BASKIN
(American)
*The Snow-Shoe Hare,
1981*

7 The Chatterton File

HENRY WALLIS • *Chatterton*

JOHN ASH • *Poor Boy: Portrait of a Painting*

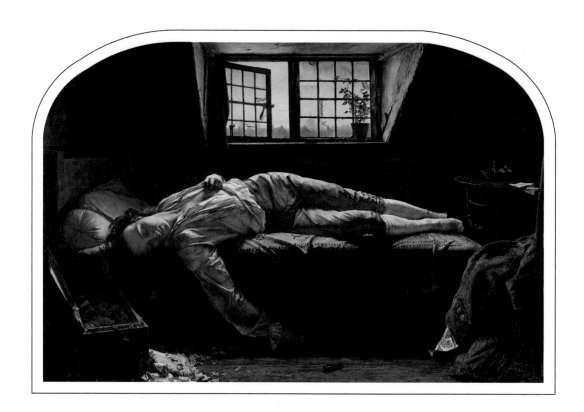

HENRY WALLIS
(British)
Chatterton, 1856. The
Tate Gallery, London

On your own

Look at the painting and imagine you are part of the scene that you are looking at. Where are you? Who are you looking at? What has happened?

1 Detective's Notes

In the summer of 1770, a London landlady reported the death of a man called Thomas Chatterton who had recently rented one of her rooms. You are the detective called to the scene. Make your own notes about this tragedy from the clues in the painting along the lines below:

Notebook entry: Date: 24 August, 1770
 Time: noon
 Place: Brooke Street, Holborn, London

- Estimated age of deceased?
- Which room in the house?
- Details of position of the body?
- Details of clothing?
- Any signs of struggle?
- Any clues in the room about reasons for the death?
- Any theory about cause of death?

In pairs

Compare notes with your partner. Then read on.

2 Further Enquiries

Later the same day you question the landlady, relatives and neighbours and establish the following facts:

- The deceased, Thomas Chatterton, was 17 years old.
- He was not a local but had come to London from Bristol earlier in the year to stay with relatives in Shoreditch. He had been living at the present address for only five weeks.
- He was a 'loner' and spent much of his time in his room writing. Examination of the papers in the room revealed many screwed up and torn up poems. Curiously, those poems on which the author's name could be deciphered were signed with various names as well as that of 'Thomas Chatterton'.
- His relatives confirmed that Thomas had previously lived with his widowed mother near the ancient church of St Mary Redcliffe, Bristol and had attended Colston's School. He was fascinated by local history and began writing poems early in his teens.
- The circumstantial evidence suggests suicide by arsenic poisoning while the balance of the mind was disturbed by his evident poverty, loneliness, and failure to gain recognition and success in literary circles in London.
- Case closed.

– *Postscript*: In 1777, it was revealed that about ten years earlier – when Chatterton was aged 15 or 16 – he had written and published a sequence of poems which he had passed off as the work of one Thomas Rowley, an imaginary fifteenth century Bristol poet. Just *why* Chatterton carried out this deception no one knows, but it is generally accepted that the poetry was written by an exceptionally gifted poet.

So much for the historical facts. Speculate with your partner about what might have led Chatterton to fake the authorship of the Rowley poems.

3 Constructing a Myth

Henry Wallis's painting of Chatterton was completed in 1856. Wallis used the young writer, George Meredith, as his model for the dead poet. Just as Chatterton had fabricated medieval poems by a medieval poet, so Wallis fabricated the scene of Chatterton's suicide for his picture. In his novel, *Chatterton* (1987), Peter Ackroyd dramatises the irony:

> 'Yes, I am a model poet,' Meredith was saying. 'I am pretending to be someone else.'
> Wallis put up his hand and stopped him.
> 'Now the light is right, now it is falling across your face. Put your head back. So.' He twisted his own head to show him the movement he needed. 'No. You are still lying as if you were preparing for sleep. Allow yourself the luxury of death. Go on.'
> Meredith closed his eyes and flung his head against the pillow. 'I can endure death. It is the representation of death I *cannot* bear.'
> 'You will be immortalised.'
> 'No doubt. But will it be Meredith or will it be Chatterton? I merely want to know.'

During the nineteenth century, the myth of Chatterton's life and death grew; Wordsworth's description of this 'marvellous boy' soon became the conventional image – one which Wallis's painting added to later in the century.

In pairs

- Talk about how this image is sustained and created by Wallis.
- Look at the painting again. List all the things that help to transform the ugly death of this impoverished 17 year old into the romantic image in the picture.

On your own

- Write your interpretation of Chatterton's story either as a detective's report (using your notes, above), or as a newspaper account from 1770 (Headline: 'Young Poet's Suicide in Garret'), or 1856 (Headline: 'New Painting by Henry Wallis in Royal Academy').

4 'And the light is art! It is arranged so . . .'

Below we have printed a further extract from Peter Ackroyd's novel
Chatterton and John Ash's poem, *Poor Boy: Portrait of a Painting*. The
extract from the novel dramatises the moments when Henry Wallis is
preparing his canvas and dwells on his thoughts about translating the
image in his mind into the medium of paint. The poem begins by
acknowledging the difficulty in understanding Chatterton's life and
death; and it ends with the idea that we must all make our own
interpretation of the painting.

Hear the extract from the novel and the poem read aloud.

On the following morning he began. He had prepared the canvas; its
glue and plaster ground was now perfectly smooth and, as he
touched it, he could feel the outline of the projected images already
guiding his finger . . . here the body would lie, and here the arm
would fall. He began mixing the flake white with the linseed oil until
he knew that it was of the right consistency, then he placed the paint
on blotting paper to remove the excess oil. Nothing is pure, he
thought, everything is stained. He took a French brush, dipped it into
the paint, and began to cover the canvas with a brilliant white
ground, working from left to right until the underpainting was
complete. He stepped back to examine the freshly painted surface,
looking for cracks or patches of uneven brightness, but it was quite
smooth. This was the stage before all colour and for a moment Wallis
wanted to strike out with his brush, to slash it or to make wild and
indecipherable marks upon it until the brightness was torn and then
dimmed for ever.

But as he watched that absolute white drying slowly on the canvas
he could already see 'Chatterton' as a final union of light and shadow:
the dawn sky at the top of the painting, softening down the light to a
half-tint with the leaves of the rose plant upturned to reflect its grey
and pink tones; the body of Chatterton in the middle of the painting,
loaded with thicker colour to receive the impact of that light; and then
a principal mass of darkness running below. Wallis already knew that
he would be using Caput Mortuum or Mars Red for the coat of
Chatterton, thrown across the chair, and that he would need Tyrian
Purple for the strong colour of his breeches. But these powerful
shades would stay in delicate contrast to the cool colours beside them
– the grey blouse, the pale yellow stockings, the white of the flesh and
the pinkish white of the sky. These cooler colours would then be
revived by the warm brown of the floor and the darker brown of the
shadows across it; and they, in turn, would be balanced by the
subdued tints of the early morning light. So everything moved
towards the centre, towards Thomas Chatterton. Here, at the still
point of the composition, the rich glow of the poet's clothes and the
brightness of his hair would be the emblem of a soul that had not yet
left the body; that had not yet fled, through the open window of the
garret, into the cool distance of the painted sky.

It was all of a piece and, in his recognition of the complete work,
Wallis knew that it could never be as perfect upon the canvas as it

now was in his understanding. He did not want to lose that perfect
image, and yet he knew that it was only through its fall into the world
that it would acquire any reality. He took up his palette and, with a
quick intake of breath, he began.

(from *Chatterton* by Peter Ackroyd)

— *Poor Boy: Portrait of a Painting* —

Difficult to say what all of this is all about.
Being young. Or simply arrogance, lack of patience –

a misunderstanding about what the word maturity
can mean when exchanged among 'real' adults . . .

I don't know what kind of plant that is, but it
is green and has a small red flower

and the glass it strives towards is latticed,
yellowish and cracked. Beyond it

roofs are bunched together like boats
in a popular harbour
and through it the inevitable light falls . . .

And the light is art! It is arranged *so*,
over the bed and the pale dead boy,
his astonishing red hair, the shirt rumpled like sculpture,

the breeches. . . . The breeches are a problem:
no one can decide whether they are blue
or mauve. Versions differ. But the light

is faultless. It can hit anything
whatever the distance –
for example, the squashed triangle of white lining
to the stiff, mulberry coloured dressing-gown,
the torn-up sheets of poems or pornography,
the oriental blade of pallor above
the boy's large, left eye-lid or even the small, brown
dope bottle lying on the scrubbed floor
almost at the bottom of the picture. Of course
much depends on the angle. Much remains
obscure, but this only enhances
these significant islands of brilliance,

exposed and absolutely
vulnerable to our interpretation:

there is nowhere he can hide the hand that rests
just above his stomach as if he still felt horribly ill.

John Ash

On your own

- Reread the two pieces and make your own jottings on each. Notice particularly how both the poem and the novelist direct us to the ways in which the painter focuses our attention on the significance of

 - *light* and *colour*
 - the *physical arrangement* of the body and the objects in the room.

In groups

- Compare notes and review *your interpretations* of the poem, the novel extracts, and the painting.

Note: Further details of Chatterton's life and poetry can be found in *Thomas Chatterton: Selected Poems*, edited by Grevel Lindop (see p. 125).

8 'Bruegel Saw It All'

PIETER BRUEGEL • *The Elder (1525?–69)**

This section, as with that on Van Gogh earlier, offers the opportunity to study one artist's work in a little more depth and to respond to the variety of poems that his paintings have provoked.

The four paintings cover a range of Bruegel's interests and techniques. The first two depict peasant scenes from his native Low Countries; *The Triumph of Death* is a vast allegorical canvas in which some of the details have references back to the Middle Ages; *Landscape with the Fall of Icarus*, a painting based on a story from classical mythology, is by contrast much lighter in its treatment.

1 Children's Games

In pairs or on your own

Look carefully at the painting opposite and list as many of the games and pastimes depicted as you can. There are dozens; one commentator claims to have identified eighty!

As you make your list, also note down anything that strikes you about the picture. Ask yourself:

- What sort of games are shown?
- What sort of people are the characters?
- Are they all children?
- Are there differences between boys' and girls' games?
- Think about how your eye is led into and around the picture.
- Jot down any thoughts you have about how the picture is composed.

Compare lists with the rest of the class.

* The surname of this family of Flemish painters is variously spelt. Pieter Bruegel the Elder was the founder and by far the most important figure. Until 1559 he spelt his name 'Brueghel' and thereafter without the 'h' which is the generally accepted spelling and the one we have adopted. His two sons, Pieter and Jan, retained the 'h' and are distinguished from the father in this way. (See *The Oxford Companion to Art*, ed. Harold Osborne.)

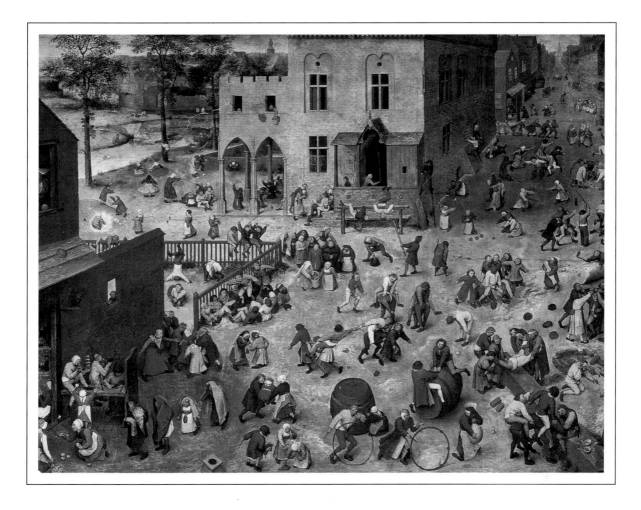

Now read William Carlos Williams' poem about the painting.

PIETER BRUEGEL
(Dutch/Flemish)
Children's Games, 1560.
Kunsthistorisches
Museum, Vienna

— *Children's Games* —

i

This is a schoolyard
crowded
with children

of all ages near a village
on a small stream
meandering by

where some boys
are swimming
bare-ass

or climbing a tree in leaf
everything
is motion

elder women are looking
after the small
fry

a play wedding a
christening
nearby one leans

hollering
into
an empty hogshead

ii

Little girls
whirling their skirts about
until they stand out flat

tops pinwheels
to run in the wind with
or a toy in 3 tiers to spin

with a piece
of twine to make it go
blindman's-buff follow the

leader stilts
high and low tipcat jacks
bowls hanging by the knees

standing on your head
run the gauntlet
a dozen on their backs

feet together kicking
through which a boy must pass
roll the hoop or a

construction
made of bricks
some mason has abandoned

iii

The desperate toys
of children
their

imagination equilibrium
and rocks
which are to be

found
everywhere
and games to drag

the other down
blindfold
to make use of

a swinging
weight
with which

at random
to bash in the
heads about

them
Brueghel saw it all
and with his grim

humor faithfully
recorded
it

William Carlos Williams

In pairs

- Can you find all the games that the poet lists in sections (i) and (ii)?
- What does the third section say about the picture?
- Many people have noticed that the groups of children in the painting
 are isolated from each other and that their movements have
 something almost distorted about them; also, that the children's faces
 are expressionless and their features more like those of old men and
 women. What do you think?

On your own

- Make your own 'list poem' – long and thin, perhaps, like this one –
 using your notes on the painting, to express what interests you in the
 picture and what thoughts and feelings it provokes.

2 Peasant Dance

Bruegel's painting shows the festivities at the annual fair, or kermess.
Look at the painting and then hear the poem read aloud.

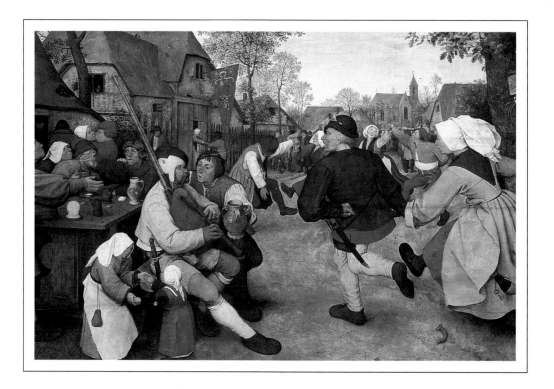

PIETER BRUEGEL
(Dutch/Flemish)
Peasant Dance, c.1567.
Kunsthistorisches
Museum, Vienna

— *The Dance* —

In Brueghel's great picture, The Kermess,
the dancers go round, they go round and
around, the squeal and the blare and the
tweedle of bagpipes, a bugle and fiddles
tipping their bellies (round as the thick-
sided glasses whose wash they impound)
their hips and their bellies off balance
to turn them. Kicking and rolling about
the Fair Grounds, swinging their butts, those
shanks must be sound to bear up under such
rollicking measures, prance as they dance
in Brueghel's great picture, The Kermess.

William Carlos Williams

In pairs

- Talk about how the poem creates the feeling of the dance.
- Think about:

 - the rhythm of the lines
 - the punctuation
 - the language
 - the details the poet focuses upon.

- Look at the faces in the painting and the movement of the figures in the poem. How would you describe the atmosphere?
- Are the two figures in the right foreground of the picture in the dance or running towards the inn?

3 The Triumph of Death

Bruegel's painting depicts a wasteland, peopled by spidery skeletons intent on gathering the living into Death's grasp. The painting is a vast *danse macabre*, yet it is made up of many individual episodes.

> A brief look at the composition once again shows Bruegel's superior skill in organizing mass scenes on a large scale, with regard to both form and content. As so often in Bruegel's work, the right-hand side of the picture is structured differently from the left, the one intensifying the other. Both halves are unified by the foreground, where five different scenes are set out at equal intervals from left to right: emperor, cardinal, pilgrim, soldiers, lovers. These are arranged with classic Renaissance symmetry, which Bruegel artfully conceals: power and love feature as extreme opposites in the corners, while between them at the centre lies the man who has renounced both power and love, the pilgrim in the white garb of the penitent. All four corners are marked by striking details: emperor and lovers are deliberately rounded in composition to fit into their corners, while the eye is drawn up to top left by the huge funeral bells and to top right by the wheel.
>
> (from *Bruegel* by Alexander Wied)

In pairs

- Look carefully at the painting and, using the diagram, information and questions we have given in the following pages, try to sort out what is going on in the picture.
- Also, list any questions you have about the painting which you want to raise in discussion.

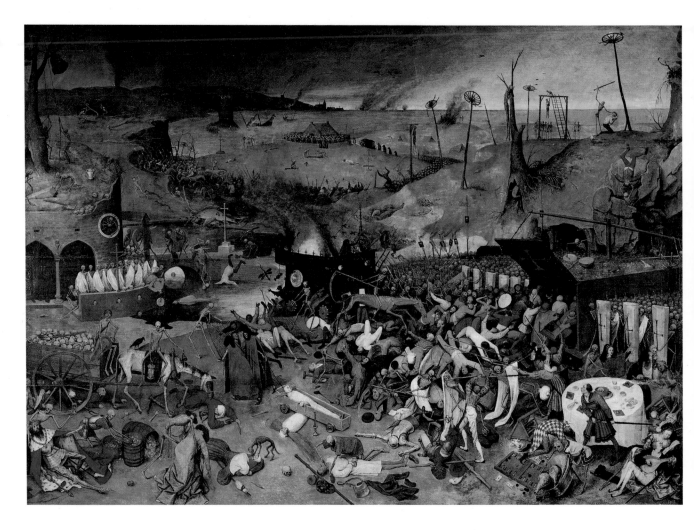

PIETER BRUEGEL
(Dutch/Flemish)
The Triumph of Death,
c.1562. The Prado,
Madrid

1 *Death the Reaper*, killing indiscriminately, astride his ravenous charger.
2 *Death Cart.* Death rides side-saddle, carrying a bell and lantern. These horse-borne skeletons are two of the most dominant figures in the painting. What is the role of their movement and direction in the overall composition of the picture?
3 *Death Trap.* Two skeletons on the edge of the picture raise a flap-like door to let through a panic-stricken mass of people who think they might escape. What does this box-like shape suggest?
4 *Furnace.* What do you think is the significance of the fiery furnace in the centre of the picture?
5 *Clergy.* A group of skeletal clergymen drown a heretic with the aid of a millstone around his neck. The symbol of the Cross is dominant. What might Bruegel be saying here? The seven groups of figures in the foreground show that Death is no respecter of persons.

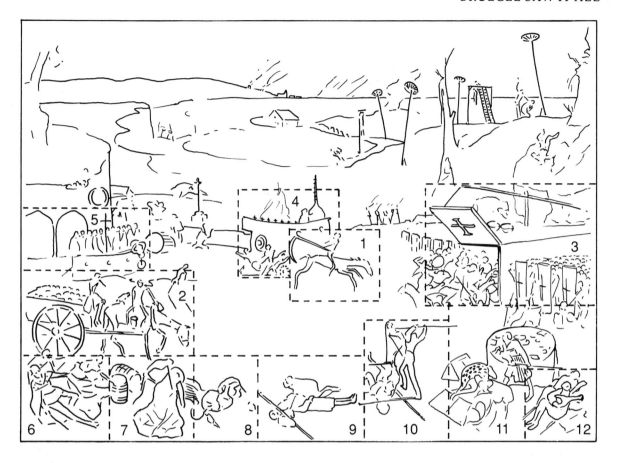

6 *Emperor.* What is the significance of the hour-glass and the barrels of
 money and jewels?

7 *Cardinal.* What is the implied relationship between the two figures
 each wearing a cardinal's hat?

8 *Mother and Baby.* Even the innocent are doomed. The mother's
 attempt to shield her child is futile. On the ground before her are
 scattered her distaff and spindle.

9 *Pilgrim.* The cap, staff and bag indicate this figure is a pilgrim – here
 shown having his throat cut by Death. How is he portrayed?

10 *Knights and Soldiers.* Knights and soldiers resist the oncoming armies
 of Death. How do their position and portrayal suggest this plight?

11 *The Revellers.* (See detail over the page.) A group of revellers,
 partying around a table laden with food and wine, are surprised by
 Death. Notice the details: the cards, the wine-skins, the
 backgammon set, the skeleton offering a skull and bones on a dish to
 a distraught lady, the fool hiding under the table. . . . This is the
 brightest and most recognisable part of the picture. What does it
 suggest about such pleasures?

12 *Lovers.* (See detail over the page). The two lovers are the only ones
 who are unaware of Death, even though he serenades them, playing
 his violin close by. How do you read the relationship between Love
 and Death here?

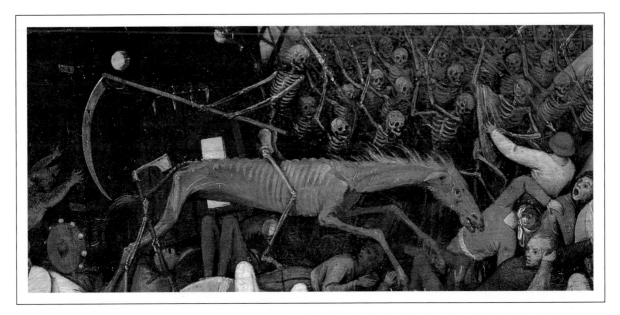

Detail 1, 'Death the Reaper' from *The Triumph of Death*

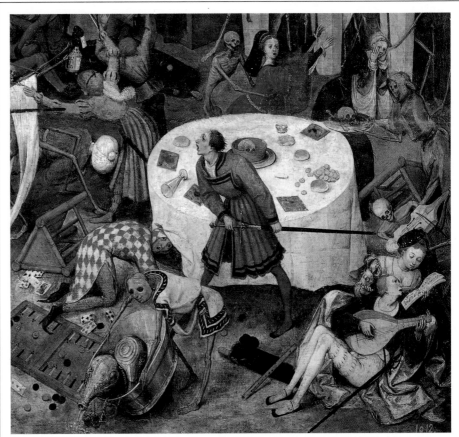

Details 11 and 12, 'The Revellers' and 'The Lovers' from *The Triumph of Death*

The lovers were Sylvia Plath's starting point for her poem suggested by the painting. Hear it read aloud.

— *In Breughel's Panorama* —

In Breughel's panorama of smoke and slaughter
Two people only are blind to the carrion army:
He, afloat in the sea of her blue satin
Skirts, sings in the direction
Of her bare shoulder, while she bends,
Fingering a leaflet of music, over him,
Both of them deaf to the fiddle in the hands
Of the death's-head shadowing their song.
These Flemish lovers flourish; not for long.

Yet desolation, stalled in paint, spares the little country
Foolish, delicate, in the lower right hand corner.

Sylvia Plath
(from *Two Views of a Cadaver Room*)

- Notice how she has painted this small word-picture through capturing the details of dress, colour, position, sounds, movements.
- What are the two seemingly contradictory ideas in the last three lines?

On your own

- Focus on one of the other details of the painting and write your own short word-picture. Your discussion of the details we have directed you towards may have suggested an idea to you, but there are plenty of other possibilities. Notice the armies of death have coffin lids as shields . . . A bloated corpse floats in the water . . . The whole landscape is barren, with fires and executions everywhere . . .

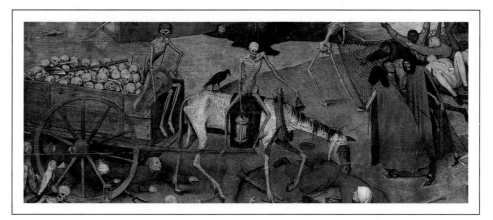

Detail 2, 'Death Cart' from *The Triumph of Death*

4 Landscape with the Fall of Icarus

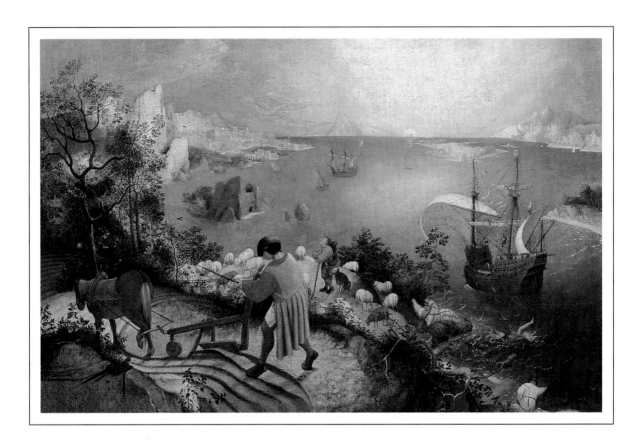

PIETER BRUEGEL
(Dutch/Flemish)
Landscape with the Fall of Icarus, c.1555. Musée Royaux des Beaux Arts, Brussels

The Fall of Icarus is the only mythological subject Bruegel painted. Icarus disobeyed his father, Daedalus, and flew too close to the sun, his wax wings melted and he plunged to his death. The victim of vanity and foolhardiness, he falls headlong into the calm estuary in the bottom right corner of the picture.

In groups

- Talk about the painting and the overall atmosphere it conveys.
- Why do you think that the main event is so reduced in importance?
- Notice the other figures – the fisherman, the shepherd and the ploughman. How do they react to Icarus' fall?

Now, in your group, share out the reading of the following three poems, hearing each one spoken aloud at least once.

- Note down two or three particular details that each writer focuses upon and talk about their significance.
- Do the poems have any ideas or feelings in common?

On your own

When you feel that you have come to terms with all three poems, choose *one* and, *on your own*, write about it, saying why you prefer it to the other two.

— *Landscape with the Fall of Icarus* —

According to Brueghel
when Icarus fell
it was spring

a farmer was ploughing
his field
the whole pageantry

of the year was
awake tingling
near

the edge of the sea
concerned
with itself

sweating in the sun
that melted
the wings' wax

unsignificantly
of the coast
there was

a splash quite unnoticed
this was
Icarus drowning

William Carlos Williams

— *Fall of Icarus: Brueghel* —

Flashing through falling sunlight
A frantic leg late plunging from its strange
Communicating moment
Flutters in shadowy waves.

Close by those shattered waters –
The spray, no doubt, struck shore –
One dreamless shepherd and his old sheep dog
Define outrageous patience
Propped on staff and haunches,
Intent on nothing, backs bowed against the sea,
While the slow flocks of sheep gnaw on the grass-thin coast.
Crouched in crimson homespun an indifferent peasant
Guides his blunt plow through gravelled ground,
Cutting flat furrows hugging this hump of land.
One partridge sits immobile on its bough
Watching a Flemish fisherman pursue
Fish in the darkening bay;
Their stillness mocks rude ripples rising and circling in.

Yet that was a stunning greeting
For any old angler, peasant, or the grand ship's captain,
Though sent by a mere boy
Bewildered in the gravitational air,
Flashing his wild white arms at the impassive sea-drowned sun.

Now only coastal winds
Ruffle the partridge feathers,
Muting the soft ripping of sheep cropping,
The heavy whisper
Of furrows falling, ship cleaving,
Water lapping.

Lulled in the loose furl and hum of infamous folly,
Darkly, how silently, the cold sea suckles him.

Joseph Langland

— *Musée des Beaux Arts* —

About suffering they were never wrong,
The Old Masters: how well they understood
Its human position; how it takes place
While someone else is eating or opening a window or just
 walking dully along;
How, when the aged are reverently, passionately waiting
For the miraculous birth, there always must be
Children who did not specially want it to happen, skating
On a pond at the edge of the wood:
They never forgot
That even the dreadful martyrdom must run its course
Anyhow in a corner, some untidy spot
Where the dogs go on with their doggy life and the torturer's
 horse
Scratches its innocent behind on a tree.

In Brueghel's *Icarus*, for instance: how everything turns away
Quite leisurely from the disaster; the ploughman may
Have heard the splash, the forsaken cry,
But for him it was not an important failure; the sun shone
As it had to on the white legs disappearing into the green
Water; and the expensive delicate ship that must have seen
Something amazing, a boy falling out of the sky,
Had somewhere to get to and sailed calmly on.

W. H. Auden

9 'The Solitary Head'

EDVARD MUNCH • *Girls on the Bridge*

EDVARD MUNCH • *The Scream*

DEREK MAHON • *Girls on the Bridge*

B. C. LEALE • *The Scream*

EDVARD MUNCH
(Norwegian)
*Girls on the Bridge,
c.1900. Wallraf-Richartz-
Museum, Cologne*

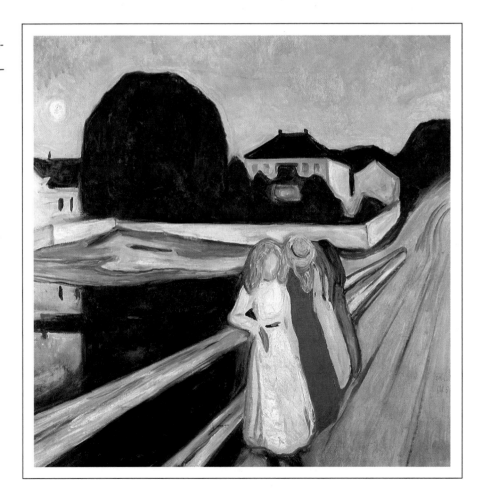

On your own

- Concentrate your attention on Munch's painting opposite.

- Place a sheet of paper alongside the picture and jot down your thoughts or impressions in the way we outlined with Renoir's *La Loge* (p. 8). Although we have included some questions to prompt you, ask your own questions too.

Look at the sun, the trees, the lake. What time of year and day is it?

What kind of neigh-bourhood is it?

What is the atmosphere of this scene?

Four girls. How old are they? What kind of families? What are they doing? What might they be thinking?

What thoughts or associations do the road and bridge bring to mind?

- If you find it helps, you can sketch the outline of the picture in the centre of your page as we have done here and jot your thoughts around it.

In pairs or small groups

- Now share your thoughts with a partner or with others in a small group before looking at the painting overleaf.

Now look at Munch's later painting, *The Scream*.

EDVARD MUNCH
(Norwegian)
*The Scream, 1893. The
National Gallery, Oslo*

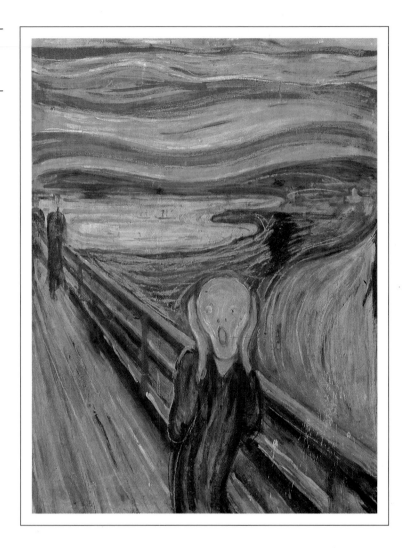

Working in pairs

- First, consider the whole picture and talk about the atmosphere and mood you find there.
- Think about the figures and ask yourself what they might represent, how they are related, and where they are.
- Look closely at the colours Munch has used and at the combination of swirling and straight lines. Discuss how these help to create the mood of the picture.
- Do you think the picture has any connection with the other one by Munch?

Listen to Derek Mahon's poem, *Girls on the Bridge*, being read aloud only after you have looked at the two pictures.

— *Girls on the Bridge* —

Audible trout,
Notional midges. Beds,
Lamplight and crisp linen, wait
In the house there for the sedate
Limbs and averted heads
Of the girls out

Late on the bridge.
The dusty road that slopes
Past is perhaps the main road south
A symbol of world-wondering youth
Of adolescent hopes
And privileges;

But stops to find
The girls content to gaze
At the unplumbed, reflective lake,
Their plangent conversational quack
Expressive of calm days
And peace of mind.

Grave daughters
Of time, you lightly toss
Your hair as the long shadows grow
And night begins to fall. Although
Your laughter calls across
The dark waters,

A ghastly sun
Watches in pale dismay.
Oh, you may laugh, being as you are
Fair sisters of the evening star,
But wait – if not today
A day will dawn

When the bad dreams
You hardly know will scatter
The punctual increment of your lives.
The road resumes, and where it curves,
A mile from where you chatter,
Somebody screams . . .

Derek Mahon

In pairs

- Talk about the poem and discuss the picture painted by the poet in the first three verses of the girls, their backgrounds and their hopes for the future.
- In the later verses, a sense of menace arises. Discuss how this feeling is created.

On your own

- Write your own poem to accompany Derek Mahon's *Girls on the Bridge* but take *The Scream* as your starting point. You may find it helpful to take up Derek Mahon's suggestion of the road linking the two pictures and to reverse the point of view. His innocent young girls do not know the bad dreams that may await them. Your screaming face might be turning desperately back, seeking the calm that once was.

 You might like to use the same syllabic verse pattern that Derek Mahon adopts for each verse – four syllables in the first line, six in the next, then two eight syllable lines, a six and a four syllable line to finish. Hence the 'diamond' shape of each verse. He doesn't stick absolutely rigidly to the pattern but you can see what he is striving for.

 You might like to know that Munch, who was undoubtedly an unhappy and unbalanced man, actually described how the image of *The Scream* was conjured up:

 > I walked along the road with two friends. The sun went down – the sky was blood red – and I felt a breath of sadness – I stood still, tired unto death – over the blue black fjord and city lay blood and tongues of fire. My friends continued on – I remained – trembling with fear, I experienced the great infinite scream through nature.
 > (diary entry, 22.1.1892, Nice)

 The painting that resulted is one of a cycle of pictures that Munch called *The Frieze of Life* in which he revealed his deepest feelings about life, love and death.

- Finally, when you have written your own poem, look at this one written in response to *The Scream*:

— *The Scream* —

A jetty
spiders out of the sea.
The sky's blood vessels break.

A sound from the unbuilt future
rises with whining shrillness –
its hot needle presses
through the base of the solitary head.
Hands valve down onto ears. Sound
earths in nerves of terror.

B. C. Leale

EDWARD HOPPER • *Nighthawks*

JULIE O'CALLAGHAN • *Nighthawks*

EDWARD HOPPER
(American)
*Nighthawks, 1942. The
Art Institute of Chicago*

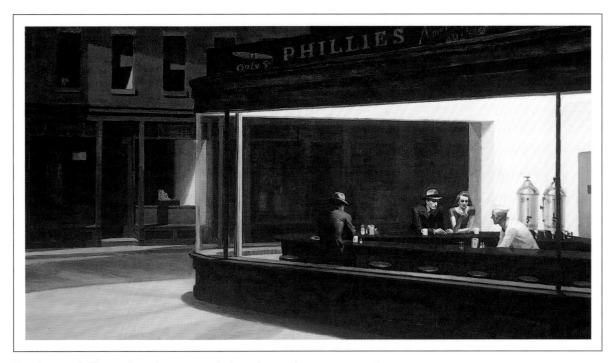

Look carefully at the picture and then hear the poem on the next page
read aloud.

— *Nighthawks* —

The heat and the dark
drive us from apartments
down empty streets
to the all-night diner
where fluorescent lights
illuminate us like tropical fish
in a fish tank.
We sit side by side
listening to glasses clank,
the waiter whistling,
and stare at the concrete outside.
Not looking at our watches
or counting the cigarettes
and cups of coffee.

Julie O'Callaghan

In pairs or small groups

- Talk about the atmosphere of the picture. You might like to consider the quality of the light and shadow and its effect on the scene; the colours; the arrangement of lines and angles.
- Discuss whether the poem captures the atmosphere of the picture as you perceive it.

EDWARD HOPPER • *Automat*

JULIE O'CALLAGHAN • *Automat*

Look carefully at the picture and then hear the poem opposite read aloud.

In pairs or small groups

- Discuss the atmosphere of the picture and how far you think the poem captures the mood of both the place and the girl. (An automat is an automatic self-service counter where the food is ready placed in scores of little plastic cupboards arranged in tiers.)

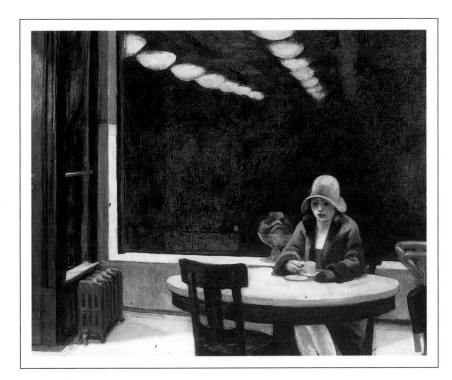

EDWARD HOPPER
(American)
*Automat. Des Moines
Art Center, Iowa*

— *Automat* —

I thought when I came here
I'd get as rich as a secretary
and marry my boss.
I dreamt about that so long
I thought it would happen.
Maybe I should go back.

I hate small places though
and when I sit eating at the automat
I pretend I'm a celebrity
and all those walls of plastic doors
are really crowds of camera lenses
waiting to take my picture.

Julie O'Callaghan

On your own

- Look back to Edward Hopper's other picture, *Nighthawks* (p. 101), and imagine you are one of the people in the scene. Write your own poem which, like Julie O'Callaghan's poem, *Automat*, attempts to capture what is going on in that character's head.

10 Poet, Painter, Politics

FRANCISCO GOYA • *The Third of May 1808* •

Panic • *Two Strangers*

SEAMUS HEANEY • *Summer 1969*

FRANCISCO GOYA
(Spanish)
*The Third of May, 1808,
1814–15. The Prado,
Madrid*

Both the poem and the paintings in this section are about violent, historical events. Both record a particular day yet also generalise about history. Both remind us that, however distant events may seem in time or place, or when mediated through television, words or paintings, such violence has an awful, unpredictable immediacy.

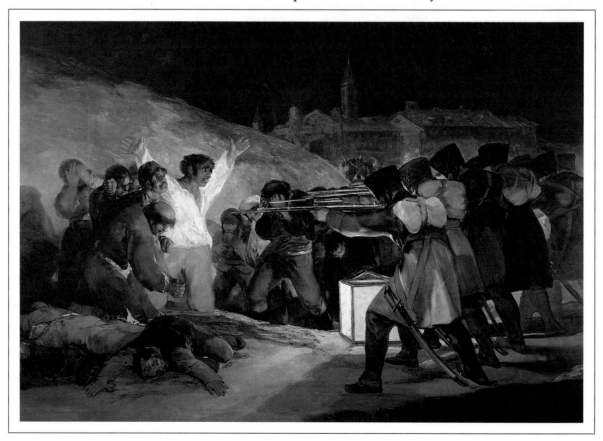

The dates are important. On 3 May 1808, the people of Madrid were fighting back against the French troops in a short-lived uprising, as Napoleon's forces took over Spain. The painting was commissioned six years after the event and Goya was asked to

> 'perpetuate with his brush the most notable and heroic actions or events of our glorious insurrection against the tyrant of Europe'.
> (from *Goya* by José Gudiol)

On 12–15 August 1969, the troubles between the Catholic and Protestant communities of Northern Ireland erupted afresh, particularly in Derry and Belfast. Two contemporary historians comment:

> By mid-August 1969 disorder had reached such a height that the police could no longer contain it, and the Northern Ireland government was obliged to request the British government to send in troops to restore order.
> (from *The Course of Irish History* edited by T. W. Moody and F. X. Martin)

Seamus Heaney, Ireland's best known contemporary poet, was working in Spain when news of the disturbances in Ireland reached him. Here is what he wrote about that summer. As you hear the poem read aloud, notice how his memories of Ireland, the television reports of the violence, and the images of Goya's paintings all merge.

— *Summer 1969* —

While the Constabulary* covered the mob * Royal Ulster Constabulary
Firing into the Falls,* I was suffering * Falls Road, Belfast
Only the bullying sun of Madrid.
Each afternoon, in the casserole heat
Of the flat, as I sweated my way through
The life of Joyce,* stinks from the fishmarket * Irish writer
Rose like the reek off a flax-dam.
At night on the balcony, gules of wine,
A sense of children in their dark corners,
Old women in black shawls near open windows
The air a canyon rivering in Spanish.
We talked our way home over starlit plains
Where patent leather of the Guardia Civil* * the national police
Gleamed like fish-bellies in flax-poisoned waters.

'Go back,' one said, 'try to touch the people.'
Another conjured Lorca* from his hill. * Spanish poet, killed 1936, during Spanish Civil War

We sat through death counts and bullfight reports
On the television, celebrities
Arrived from where the real thing still happened.

I retreated to the cool of the Prado.
Goya's 'Shooting of the Third of May'
Covered a wall – the thrown-up arms
And spasm of the rebel, the helmeted
And knapsacked military, the efficient
Rake of the fusillade. In the next room
His nightmares, grafted to the palace wall –
Dark cyclones, hosting, breaking; Saturn* * two ancient gods
Jewelled in the blood of his own children,
Gigantic Chaos* turning his brute hips
Over the world. Also, that holmgang* * a violent duel
Where two berserks club each other to death
For honour's sake, greaved in a bog, and sinking.

He painted with his fists and elbows, flourished
The stained cape of his heart as history charged.

 Seamus Heaney

On your own

- Now, read the poem through slowly to yourself, thinking about the
 feelings and ideas in its four unequal sections as you go. Jot down,
 about *each* section:

 - the main *mental pictures* that the words suggest to you
 - any *thoughts or feelings* that Seamus Heaney expresses
 - any bits that puzzle you.

In groups

- Use your notes to talk about the poem.
- Notice where your 'readings' agree or diverge, sort out the parts that
 puzzle you, decide what you like/dislike about the poem.
- As a way of focusing the group's thoughts, you could try to agree on
 three or four phrases *from the poem* which sum up its character and
 meaning for you. Share your selections with the rest of the class.

In pairs or groups

- Now look more closely at the main paintings that Seamus Heaney mentions. *The Third of May, 1808* shows a group of Spaniards cowering in panic in front of the French firing squad. Look at their expressions, the positions of all the figures, the colours and lighting of the scene; talk about how Goya has created the sense of horrifying realism.

 Panic shows one of the ancient gods, 'Gigantic Chaos turning his brute hips / Over the world', as Seamus Heaney phrases it.

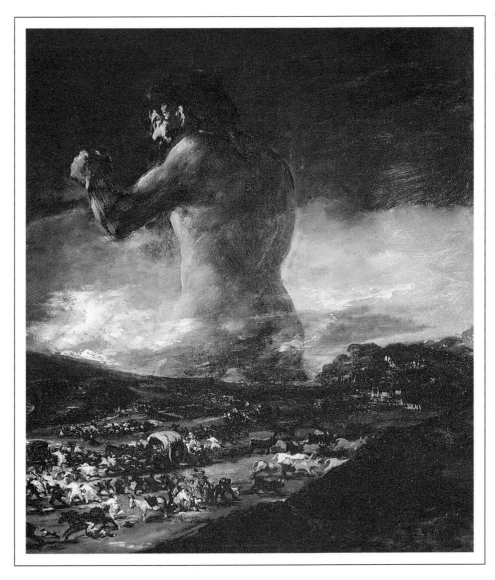

FRANCISCO GOYA
(Spanish)
Panic c.1810–12. The Prado, Madrid

- Think about the positioning and movement of the giant, the reaction of the people and creatures on the plain, and, again, the colours and lighting of the scene.
- How do you respond to this more generalised picture of violence compared with that in *The Third of May, 1808*? Compare your reactions.
- Now look at Goya's *Two Strangers* fighting each other with clubs (the 'holmgang' of the poem). It is a more localised portrait of violent action. What feelings come through in the way Goya depicts the scene?

FRANCISCO GOYA
(Spanish)
Two Strangers (detail),
The Prado, Madrid

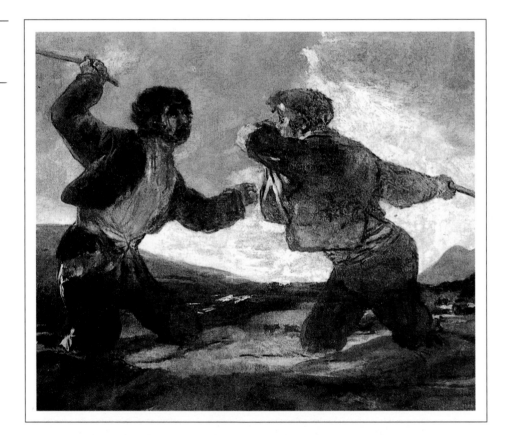

- Look back at your reactions to Seamus Heaney's poem. How do the images of violence in the paintings compare with those with which we are presented daily on our television screens and in the newspapers?

11 Gallery Visit

All the paintings in this section are from the Tate Gallery in London. Some are accompanied by poems that were suggested by the paintings but most are left for *you* to write about. The paintings were chosen by students of around your own age as ones they found interesting on their gallery visits.

Browse through these pages as you might take a walk around an art gallery, pausing when something catches your interest. Find one or two paintings about which you can write your own poems. You could then make up your own wall display of paintings and poems using posters, and postcard reproductions.

Best of all, you could make this into a real gallery visit either to the Tate or to a more local collection (see *Gallery Information* on p. 126). From your visit you could make your own anthology of paintings and poems as an alternative section to the one we have printed here. You might also combine this collection with the compilation of a Student Guide (see *Making Connections* p. 119, number 5).

GWEN JOHN • *A Lady Reading*
JENNY JOSEPH • *A Chair in My House:*
After Gwen John

— *A Chair In My House:* After Gwen John —

The house is very still and it is very quiet.
The chair stands in the hall: lines on the air;
Bar back, a plane of wood, focus in a space
Polished by dusk and people who might sit there.

Pieces of matter have made it. To get in words
What you could do in paint
Only the simplest sentences will serve.

And in this presence how much 'elsewhere' lurks.
It is a sort of listening to the air
That laps the object, a breathing in of light
That's needed if we are to see the chair.

Here I pare this little stick of words
To keep away the crowds
And set my chair down, which words can never do.

The yellow daisies clash in the wind outside
It's not for long we can ignore they're there
Your noisy letters are dead in a box in the town
Your pictures breathe this wordless atmosphere.

The day goes through the room: dusk, white wall, through
To dusk again, and my wooden chair stands there.
I cannot get my chair the way you do
The things you paint.
Even the simplest sentence will not do.

Jenny Joseph

GWEN JOHN (British)
A Lady Reading, 1907–8.
The Tate Gallery, London

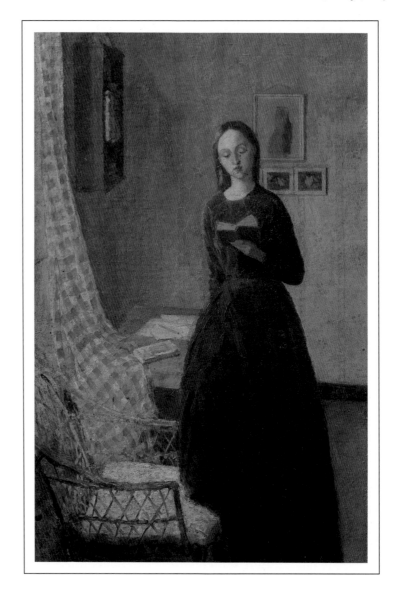

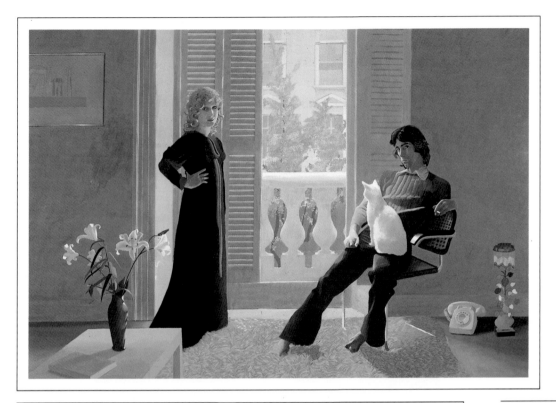

DAVID HOCKNEY
(British)
Mr and Mrs Clark and Percy, 1970–71. *The Tate Gallery, London*

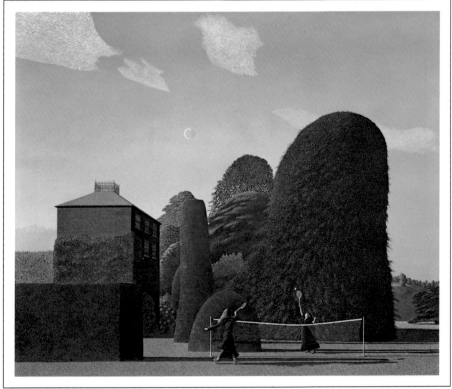

DAVID INSHAW
(British)
The Badminton Game, 1972–3, The Tate Gallery, London

MARK GERTLER
(British)
The Merry-go-Round,
1916. The Tate Gallery,
London

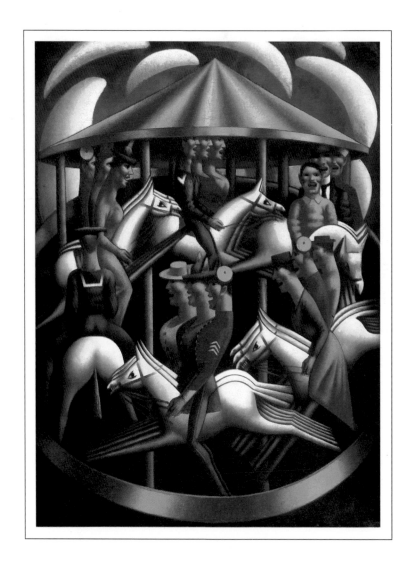

PATRICK CAULFIELD
(British)
*Pottery, 1969. The Tate
Gallery, London*

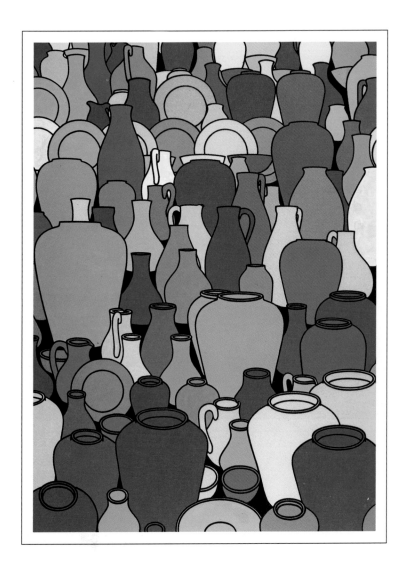

J. M. W. TURNER
(British)
Snowstorm: Steam-Boat
off a Harbour's Mouth,
1842. The Tate Gallery,
London

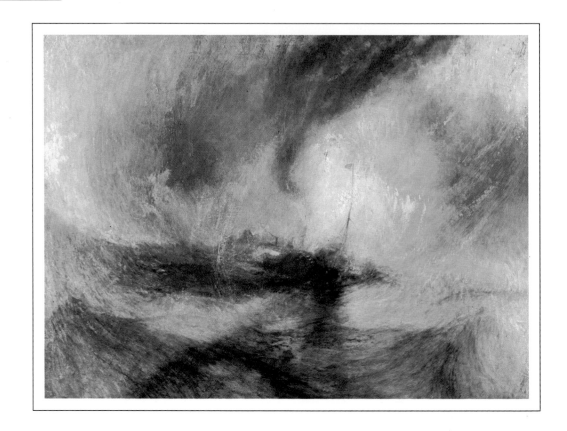

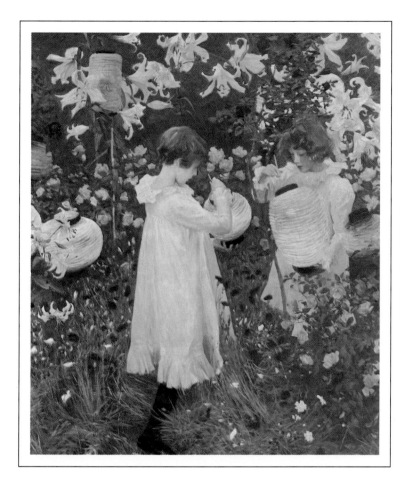

JOHN SINGER
SARGENT (British)
*Carnation, Lily, Lily,
Rose, 1885–6. The Tate
Gallery, London*

DOUBLE VISION

FRANCIS BACON
(British)
*Seated Figure, 1961. The
Tate Gallery, London*

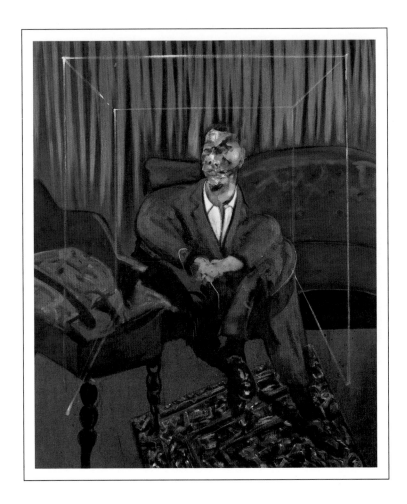

— *Leaving the Tate* —

Coming out with your clutch of postcards
in a Tate Gallery bag and another clutch
of images packed into your head you pause
on the steps to look across the river

and there's a new one: light bright buildings,
a streak of brown water, and such a sky
you wonder who painted it – Constable? No:
too brilliant. Crome? No: too ecstatic –

a madly pure Pre-Raphaelite sky,
perhaps, sheer blue apart from the white plumes
rushing up it (today, that is,
April. Another day would be different

but it wouldn't matter. All skies work.)
Cut to the lower right for a detail:
seagulls pecking on mud, below
two office blocks and a Georgian terrace.

Now swing to the left, and take in plane-trees
bobbled with seeds, and that brick building,
and a red bus . . . Cut it off just there,
by the lamp-post. Leave the scaffolding in.

That's your next one. Curious how
these outdoor pictures didn't exist
before you'd looked at the indoor pictures,
the ones on the walls. But here they are now,

marching out of their panorama
and queuing up for the viewfinder
your eye's become. You can isolate them
by holding your optic muscles still.

You can zoom in on figure studies
(that boy with the rucksack), or still lives,
abstracts, townscapes. No one made them.
The light painted them. You're in charge

of the hanging committee. Put what space
you like around the ones you fix on,
and gloat. Art multiplies itself.
Art's whatever you choose to frame.

Fleur Adcock

117

12 Making Connections

Themes and Projects

1 Anthology-making

Either individually or as a class, collect favourite paintings in postcard versions. Write poems to accompany them. Present your anthology as a book or wall display.

2 Posters

Make a 'poster-wall' in your classroom which is given over to large-scale reproductions of paintings. First, write to the main London galleries (addresses on p. 126) for their catalogues to find out what is available. Explore your local galleries, too.

Your 'poster-wall' might feature a single artist one month, a particular movement (Impressionists, Pre-Raphaelites, etc.) the next, a theme (landscapes, portraits . . .) the next, and so on. You may want to explore other areas not covered in this book, for example, African, Caribbean, Mexican, Indian or Japanese art. Although our selection is largely representational art, there is no reason why you should not choose work based on abstract patterns. Whatever your choice, annotate your selection with brief notes about the artists, any information you can find about the paintings, and poems in response to the pictures.

3 Tape/slide presentation

Devise a sequence of poems/paintings as a tape/slide programme for a specific audience – maybe for students in another group or school, or for an assembly. Select your sequence carefully to develop a particular theme or to focus on a particular painter. Introduce your programme, script your linking passages and look for opportunities to include some of your own creative work.

Clearly, the easiest source of slides is to buy them from the galleries. You can put together a good programme with only four or five slides and they are generally inexpensive, about 50p each.

4 Storytelling

'Every picture tells a story' so they say. Every painting in this book has a story embedded within it or one that could be invented about it. Choose a painting from here or elsewhere and develop its story, either orally or in writing.

5 Gallery visit: making a *Student Guide*

Visit your nearest art gallery or one of the main city galleries. It is useful to have a specific aim. Yours could be simply to find two or three paintings that really appeal to you. Find out as much as you can about your choices – when and where they were painted, who or what is portrayed, any other information about the painter. Buy a postcard or find a reproduction of the paintings to help you remember the details.

Write a *one page account* of your choices, including the information you have discovered and the reasons why you like the paintings. If everyone in the group does this, you could put your pages together into a *Student Guide* for other school or college groups to use. (Don't forget that galleries often have an education officer.)

6 'Desert Island' paintings

Which six paintings would you choose to have with you on a desert island? You may well need to browse through some books of paintings (many of those on our list on p. 125 should be available in libraries) as well as listing those that are favourites already.

Compare lists and see if there are paintings or painters that are specially popular. (We found that Van Gogh and Bruegel were popular with poets.)

If you could have just *one* painting on your island, which would it be? Write about the feelings and thoughts this painting gives you, either as a prose description or as a poem.

7 Men and women

Several of the painting/poem combinations in this collection are concerned with images of men and women and, as the great majority of the painters are male and often pre-twentieth century, they are likely to offer a specifically male view of those images that reflects the attitudes of their own times.

Look back at Renoir's *La Loge* (p. 8); Klimt's *The Kiss* (p. 24); Van Eyck's *The Arnolfini Marriage* (p. 21); *St George and the Dragon* by Uccello (p. 30); *The Rescue of Andromeda* by Burne-Jones (p. 34); *The Siesta* by Lewis (p. 28); *The Lady of Shalott* by Waterhouse (p. 68); and Edward Hopper's *Automat* (p. 103). The first five paintings show men and women: the final three depict women by themselves.

In groups

Talk about the way men and women are portrayed in some of these paintings. Here are some questions to help you think about the topic:

- Where men and women are shown together in these paintings, what role does each play?
- Who is active and who is passive?
- Who, if anybody, holds the power?
- When women are depicted alone, is a partner (male?) implied?
- Is the viewer ever invited to be a voyeur?
- Are there any similarities across the centuries in the way the painters have depicted male and female roles?
- Do you think these same topics would have been treated differently by female painters?
- Is there any similarity between the images of women presented in these paintings and those more commonly found in advertisements today?
- Half the poems that accompany these paintings are by women of the twentieth century: do their poems reflect the same values and attitudes as those of the painters?

On your own

When you have discussed the depiction of male and female roles, write an essay on the topic, basing it on a selection of paintings from this book and/or, if you wish, on other paintings with which you are familiar. You may choose simply to focus in detail on, say, one or two paintings – for example, the Uccello and the Burne-Jones – if you wish.

8 Religious images

Inevitably, this collection reflects the strong Christian traditions of much western European painting – sometimes quite overtly, occasionally rather obliquely. Christian symbols and iconography have a role in Van Eyck's *The Arnolfini Marriage* (p. 21); Gotch's *Alleluia* (p. 37); Van Gogh's *Starry Night* (p. 46); Blake's *The Tyger* (p. 51); and both the Palmer

paintings – *Coming From Evening Church* (p. 52) and *Late Twilight* (p. 55).
They are also the foundation of Bruegel's *The Triumph of Death* (p. 88).

In groups

Talk about the way the artists have drawn on religious symbols and belief
in some of these paintings. Ask yourself whether religion seems to evoke
similar things for each of them. Look, for example, at Palmer's *Coming
From Evening Church* and Van Gogh's *Starry Night*. Both show a small
community beneath the heavens: are they totally different or are they
similar in any way? Do you see any connections between the painters'
views?

On your own

After you have discussed this theme, you may feel able to write an essay
about it, connecting ideas from different paintings. Or, you may find it
helpful to concentrate on just one painting or one artist from the point of
view of their religious concerns. The list of *Books To Take You Further* (p.
124) may help you here.

9 Word-Pictures

Look back to Jenny Joseph's poem about Gwen John's painting *A Chair in
my House* (p. 109). She has tried to take up the challenge to 'get in words'
what Gwen John does in paint. Choose any painting from this book or
elsewhere (if possible one which contains a detail that has a counterpart
in your own life) and write your own poem about it.

The Poets

Brief biographical information, where available, about each of the poets whose work is featured in this volume is given, together with a single collection representative of the poet's work.

Anna Adams b. 1926, Surrey. She is an artist and ceramicist as well as a writer. *Dear Vincent*, Littlewood Press, 1986.

Fleur Adcock b. 1934, New Zealand. Has lived in England since 1963. Editor of several anthologies as well as a writer. *Selected Poems*, Oxford University Press, 1983.

John Ash *The Goodbyes*, Carcanet Press, 1982.

W. H. Auden 1907–1973. A major twentieth century poet. He drove an ambulance on the Republican side in the Spanish Civil War. Winner of several literary prizes and Professor of Poetry at Oxford 1956–60. *Collected Shorter Poems 1927–57*, Faber and Faber, 1966.

Francis Barker b. 1948. The poem in this collection was written when he was a sixth form student.

William Blake 1757–1881. Visionary poet and artist. *Songs of Innocence and Experience*, Oxford University Press.

Charles Causley b. 1917, Launceston, Cornwall. Queen's Gold Medal for Poetry 1967. Teacher. Verse much influenced by his wartime naval experience and by a strong Christian commitment. *Collected Poems 1951–75*, Macmillan, 1975.

Samuel Taylor Coleridge 1772–1834. A major Romantic poet and critic. Collaborated with Wordsworth on their *Lyrical Ballads* (1798) which contained *The Ancient Mariner*. The version of this poem containing Doré's engravings is published by Dover Books. The standard edition of *Collected Poems* is from Oxford University Press.

Martyn Crucefix b. 1956. Winner of a Gregory Award for poetry and has published several poems related to paintings.

U. A. Fanthorpe was a teacher for sixteen years. Started writing when she became a clerk/receptionist in a Bristol Hospital. *Selected Poems*, King Penguin, 1986.

Lawrence Ferlinghetti Associated with the 'Beat' generation of poets in the 1950s and 1960s. *A Coney Island of Mind*, New Directions/Hutchinson, 1958.

Seamus Heaney b. 1939, County Derry, Ireland. Father a farmer and cattle dealer. One of eight children. Teacher and lecturer in both Belfast and Dublin and the USA. He was elected Professor of Poetry at Oxford University, 1989. He is now regarded as a major poet. *Selected Poems*, Faber and Faber, 1980.

Phoebe Hesketh has published ten other collections of her poems apart from *The Eighth Day: Selected Poems 1948–78*, The Enitharmon Press, 1980.

Ted Hughes b. 1930, West Yorkshire. Ranked as a major voice since his debut in the late 1950s, he has continud to write powerful poems and stories for children as well as adults. Poet Laureate. *Selected Poems 1957–81*, Faber and Faber, 1982.

Jenny Joseph b. 1932. Read English at Oxford and worked as lecturer, reporter and pub landlady. Lives in Gloucestershire. *Beyond Descartes*, Secker and Warburg, 1983.

Sylvia Kantaris First a French Tutor at Queensland University, later an Open University Tutor, now mainly a freelance writer and performer living in Cornwall. *The Sea at the Door*, Secker and Warburg, 1985.

B. C. Leale b. 1930, London, where he lives and works as a bookseller. *The Colour of Ancient Dreams*, John Calder, 1984 is a collection of surreal poems.

Grevel Lindop b. 1948, Liverpool. Senior Lecturer in English, Manchester University. *Tourists*, Carcanet Press, 1987.

Michael Longley b. 1939, Belfast. Schoolteacher for several years. Now works for the Arts Council of Northern Ireland. *Poems 1963–83*, King Penguin, 1986.

Roger McGough One of the Mersey Poets of the 1960s, his output of verse for both children and adults is considerable, 25 years on. *Melting into the Foreground*, Penguin, 1987.

Derek Mahon b. 1941, Belfast. Lived in London. For a time poetry editor of *The New Statesman*. Currently lives in Cork. *The Hunt by Night*, Oxford University Press, 1982.

John Mole b. 1941. Co-founder and editor of the Mandeville Press, Hertfordshire. *Homing*, Secker and Warburg, 1987.

Paul Muldoon b. 1951, County Armagh, Northern Ireland. Radio and television producer, Belfast. *Selected Poems 1968–83*, Faber and Faber, 1986.

Julie O'Callaghan b. 1954, Chicago. Lives in Ireland and works in the library of Trinity College, Dublin. *Edible Anecdotes and Other Poems*, Dolmen Press, 1983.

Gareth Owen Poet, playwright and novelist. *Song of the City*, Collins, 1987.

Samuel Palmer 1805–81. Visionary artist and occasional poet.

Sylvia Plath 1932–63, b. Boston, Mass., USA. Studied Cambridge, England. Married Ted Hughes. Wrote most of her published poems in the last three to four years of her life. *Ariel*, Faber, 1966.

Connie Rosen Educationist and writer who died in the mid-1970s.

Colin Rowbotham b. 1949, Manchester. Since 1972, has lived and worked in inner London as a teacher. *Total Recall*, Littlewood Press, 1987.

Anne Sexton 1928–74, b. Newton, Mass., USA. Published six books of poetry and in 1967 was awarded the Pulitzer Prize for poetry for *Live or Die*, Houghton Mifflin, 1984

James O. Taylor The poem in this collection was written when he was a sixth form student.

Alfred, Lord Tennyson 1809–92. A major Victorian poet. Became Poet Laureate in succession to Wordsworth in 1850. There are many editions of his work available.

William Carlos Williams 1883–63, b. Rutherford, New Jersey, USA. Studied medicine. Travelled extensively in Europe. *Selected Poems* ed. Charles Tomlinson, Penguin, 1976.

Books to Take you Further

Apart from the first two titles in the General list, these selections focus on painting; lists of poetry books will be found in our companion volume, *Examining Poetry*. The General list will help you in learning to look at a wide variety of paintings; the second list is based solely on painters represented in this book.

General

Dannie and Joan Abse (eds)	*Voices in the Gallery*	The Tate Gallery
Pat Adams (ed.)	*With a Poet's Eye*	The Tate Gallery
Michael Cassin	*More than meets the eye: a closer look at paintings in the National Gallery*	National Gallery
Kenneth Clark	*Looking at Pictures*	John Murray
Robert Cumming	*Just Look*	Kestrel
Robert Cumming	*Just Imagine*	Kestrel
E. H. Gombrich	*The Story of Art*	Phaidon
Marina Vaizey	*100 Masterpieces of Art*	Artis Publishing Company
Piero Ventura	*Great Painters*	Kingfisher Books
Susan Woodford	*Looking at Pictures* (Cambridge Introduction to the History of Art)	Cambridge University Press

Individual Painters and Movements

Bruce Bernard (ed.)	*Vincent by Himself*	Orbis Publishing
Blanche Cirker (ed.)	*1800 Woodcuts by Thomas Bewick and His School*	Dover Publications
Samuel Taylor Coleridge *illus.* Gustav Doré	*The Rime of the Ancient Mariner*	Dover/Constable
William Gaunt	*The Impressionists*	Thames & Hudson
José Gudiol	*Goya*	Ediciones Polígrafa SA
John House	*Monet: Nature into Art*	Yale University Press
Ted Hughes *illus.* Leonard Baskin	*Under the North Star*	Faber and Faber
Sir Geoffrey Keynes (ed.)	*William Blake, Songs of Innocence and Experience* (illuminated edition)	Oxford University Press/ Trianon

Raymond Lister	*The Paintings of Samuel Palmer*	Cambridge University Press
Robin Marsack	*Thomas Bewick*	Carcanet Press
Gregory Martin	*Breughel*	Bracken Books
Keith Roberts	*Italian Renaissance Painting*	Phaidon
John Boulton Smith	*Munch*	Phaidon
Julian Spalding	*Lowry*	Phaidon
	and Watercolours	
Christopher Wood	*The Pre-Raphaelites*	Weidenfeld and Nicolson

Note: You may wish to buy some books about your favourite painters.
Art books can be expensive so it is probably best to begin with books
from one of the paperback series that are available. The following series
are worth exploring. As a general guide, the information about the artists
and their work is reliable but good quality colour reproductions only
come in 3 and 4 below.

1 Dolphin Art books, published by Thames & Hudson
2 World of Art series, published by Thames & Hudson
3 Penguin Classics of World Art, published by Penguin
4 Phaidon paperbacks, published by Phaidon

Other books mentioned in the text

Peter Ackroyd (1987) *Chatterton*, Hamish Hamilton.
Anna Adams (1986) *Dear Vincent*, Littlewood Press.
Grevel Lindop (ed.) (1972) *Thomas Chatterton: Selected Poems*, Carcanet.
T. W. Moody and F. X. Martin (eds) (1987) *The Course of Irish History*, The
Mercia Press.
Julian Spalding (1979) *Lowry*, Phaidon.

For more information about Perseus, contact Southampton City Art
Gallery, Civic Centre, Commercial Road, Southampton SO9 4XF for their
information booklet, *The Perseus Story*.

For a full list see *Museums and Galleries in Great Britain and Ireland* (ABC Historic Publications). Times of opening are Monday–Saturday (Sunday). For bank holidays and festivals, visitors are advised to check opening times in advance. STD codes given are from London.

Aberdeen
Art Gallery and Museums, Schoolhill. 10–5; Thu 10–8 (2–5). Tel: 0224 646333
Belfast
Ulster Museum, Botanic Gardens BT9 5AB. Mon–Fri 10–4.50; Sat 1–4.50 (2–4.50). Tel: 0232 381251
Birmingham
City Museum and Art Gallery, Chamberlain Square B3 3DH. 9.30–5 (2–5). Tel: 021-235 2834
Barber Institute of Fine Arts. The University B15 2TS. Normally open to the public (parties by appointment only). 10–5; Sat 10–1, except when the University is closed. Tel: 021-472 0962
Bristol
City of Bristol Museum and Art Gallery, Queen's Road BS8 1RL. 10–5 (closed Sundays). Tel: 0272 29971
Cambridge
Fitzwilliam Museum, Trumpington Street. Tues–Fri 10–5 (lower galleries 10–2; upper galleries 2–5); Sat 10–5 (2.15–5). For details contact the museum. Tel: 0223 332900
Cardiff
National Museum of Wales. Tues–Sat 10–5 (2.30–5). Closed Mondays. Tel: 0222 397951
Dublin
National Gallery of Ireland, Merrion Square, West 2. 10–6; Thu 10–9 (2–5). Tel: 0001 615133
Edinburgh
National Gallery of Scotland, The Mound EH2 2EL. 10–5 (2–5). Tel: 031-556 8921
Scottish National Gallery of Modern Art, Belford Road EH4 3DR. 10–5 (2–5). Tel: 031-556 8921
Scottish National Portrait Gallery, Queen Street EH2 1JD. 10–5 (2–5). Tel: 031-556 8921
Glasgow
Art Gallery and Museum, Kelvingrose. 10–5 (2–5). Tel: 041-357 3929
Burrell Collection, 2060 Pollokshaws Road G43 1AT. 10–5 (2–5). Tel: 041-649 7151
Hunterian Art Gallery, 82 Hillhead Street. Mon–Fri 9.30–5; Sat 9.30–1. Closed Sundays. Tel: 041-339 8855 ext. 7431
Pollok House, 2060 Pollokshaws Road. 10–5 (2–5). Tel: 041-632 0274
Hull
Ferens Art Gallery, Queen Victoria Square. 10–5 (1.30–4.30). Tel: 0482 222750
Leeds
City Art Gallery. Mon–Fri 10–6 (late night opening, Wed until 9pm); Sat 10–4 (2–5). Henry Moore Centre for the Study of Sculpture. Mon–Fri 10–1; 2–5 (or by appointment). Tel: 0532 462495
Liverpool
Walker Art Gallery, William Brown Street L3 8EL. 10–5 (2–5). Tel: 051-207 0001
Sudley Art Gallery, Mossley Hill Road. 10–5 (2–5). Tel: 051-724 3245
Lady Lever Art Gallery, Port Sunlight. 10–5 (2–5). Tel: 051-645 3623
Tate Gallery Liverpool, Albert Dock L3 4BB. Tues–Sat 11–7 (11–7). Closed Mondays. Tel: 051-709 3223

Manchester
City Art Gallery, Mosley Street. 10–6 (2–6). Tel: 061-236 9422
Whitworth Art Gallery, University of Manchester, Oxford Road. 10–5; Thu 10–9. Closed
Sunday. Tel: 061-273 4865
Newcastle upon Tyne
Laing Art Gallery, Higham Place. Mon–Fri 10–5.30; Sat 10–4.30 (2.30–5.30). Tel: 0632
327734/326989
Oxford
Ashmolean Museum of Art and Archaeology. Tues–Sat 10–4 (2–4). Tel: 0865 278000
Sheffield
Graves Art Gallery, Surrey Street 1. 10–8.30 (2–5). Tel: 0742 734781
Mappin Art Gallery, Weston Park. 10–5 (2–5). Tel: 0742 726281/754091
Ruskin Gallery, 101 Norfolk Street. Mon–Fri 10–7.30; Sat 10–5. Closed Sundays. Tel: 0742
734781
Southampton
Art Gallery, Civic Centre. Tue–Fri 10–5; Thu 10–8; Sat 10–4 (2–5). Closed Mondays. Tel:
0703 223855 769
Swansea
Swansea Museum Service, Glynn Vivian Art Gallery and Museum, Alexandra Road.
10.30–5.30 (10.30–5.30). Tel: 0792 55006

LONDON GALLERIES

British Museum
Great Russell Street WC1B 3DG. 10–5 (2.30–6). Tel: 636 1555
Courtauld Institute Galleries
Somerset House, Strand, London, WC2R ORN. 10–5 (2–5). Tel: 873 2526
Dulwich Picture Gallery
College Road SE21. Tue–Sat 10–1; 2–5 (2–5). Closed Mondays. Tel: 693 5254
Iveagh Bequest, Kenwood
Hampstead Lane NW3. Apr–Sep 10–7 (10–7); Oct 10–5 (10–5); Nov–Jan 10–4 (10–4);
Feb–Mar 10–5 (10–5). Tel: 348 1286
Leighton House
12 Holland Park Road W14. 11–5. Mon–Sat. Closed public holidays. 11–6 Mon–Fri; 11–5
Sat during temporary exhibitions. Tel: 602 3316
William Morris Gallery
Lloyd Park, Forest Road E17 4PP. Tue–Sat 10–1, 2–5. Closed Mondays (1st Sun of the
month 10–12, 2–5). Tel: 527 5544 ext. 4390
National Gallery
Trafalgar Square WC2N 5DN. 10–6 (2–6). Tel: 839 3321
(Publications 839 1912)
National Portrait Gallery
St Martin's Place WC2H 0HE. 10–5; Sat 10–6 (2–6). Tel: 930 1552
The Queen's Gallery
Buckingham Palace SW1. Tue–Sat 10.30–5 (2–5). Closed Mondays (except bank holidays).
Tel: 930 4832
Tate Gallery
Millbank SW1P 4RG. 10–5.50 (2–5.50). Tel: 821 1313 (Publications 834 5651/2)
Victoria and Albert Museum
Cromwell Road SW7. Mon–Thur and Sat 10–5.50 (2.30–5.50). Closed Fridays. Tel: 589 6371
ext. 372
Wallace Collection
Manchester Square W1. 10–5 (2–5). Tel: 935 0687

ART GALLERY AND
MUSEUM
BURRELL
COLLECTION
HUNTERIAN ART
GALLERY
POLLOK HOUSE

NATIONAL GALLERY
OF SCOTLAND
SCOTTISH NATIONAL
GALLERY OF
MODERN ART
SCOTTISH NATIONAL
PORTRAIT GALLERY

ART GALLERY AND
MUSEUMS

LAING ART GALLERY

CITY ART GALLERY
WHITWORTH ART
GALLERY

CITY ART GALLERY

GRAVES ART
GALLERY
MAPPIN ART
GALLERY
RUSKIN GALLERY

LADY LEVER ART
GALLERY
SUDLEY ART
GALLERY
TATE GALLERY
WALKER ART
GALLERY

FERENS ART
GALLERY

ULSTER MUSEUM

NATIONAL GALLERY
OF IRELAND

ASHMOLEAN
MUSEUM OF ART AND
ARCHAEOLOGY

FITZWILLIAM
MUSEUM

Aberdeen

Glasgow Edinburgh

Belfast

Newcastle
upon Tyne

Leeds

Manchester

Dublin

Liverpool Sheffield

Hull

Salford

Birmingham

Cambridge

Swansea
Cardiff

Oxford

ART GALLERY

SALFORD MUSEUM
AND ART GALLERY

Bristol LONDON

CITY MUSEUM AND
ART GALLERY
BARBER INSTITUTE
OF FINE ARTS

Southampton

SWANSEA MUSEUM
SERVICE

NATIONAL MUSEUM
OF WALES

CITY OF BRISTOL
MUSEUM AND ART
GALLERY

BRITISH MUSEUM
COURTAULD
INSTITUTE
GALLERIES
DULWICH PICTURE
GALLERY
IVEAGH BEQUEST,
KENWOOD
LEIGHTON HOUSE
WILLIAM MORRIS
GALLERY

NATIONAL GALLERY
NATIONAL PORTRAIT
GALLERY
THE QUEEN'S
GALLERY
TATE GALLERY
VICTORIA AND
ALBERT MUSEUM
WALLACE
COLLECTION